More BUSINESS CARDS

ROCKPORT
PUBLISHERS

Rockport Publishers, Inc
Gloucester, Massachusetts
Distributed by North Light Books
Cincinnati, Ohio

First published in the United States of America by:
Rockport Publishers, Inc.
33 Commercial Street
Gloucester, Massachusetts 01930-5089
Telephone: (978) 282-9590
Facsimile: (978) 283-2742

Distributed to the book trade and art trade in the United States by:
North Light Books, an imprint of
F & W Publications
1507 Dana Avenue
Cincinnati, Ohio 45207
Telephone: (800) 289-0963

Other Distribution by:
Rockport Publishers, Inc.
Gloucester, Massachusetts 01930-5089

ISBN 1-56496-438-8

10 9 8 7 6 5 4 3 2 1

Production: Sara Day Graphic Design
Cover Images: (clockwise) pp. 34, 51, 31, 5, 61, 68, 14, 36, 24, 76, 47

Printed in Hong Kong by Midas Printing Limited.

INTRODUCTION

Don't let the small size fool you—the business card is one of the most important pieces of corporate identity a business or person has. It is sometimes the only piece of information left behind after a contact is made; just a small, but insistent, reminder of a person after their physical presence is gone. Everybody has a business card: all sizes and types of businesses, even individuals create a card. It is the common denominator at all business meetings

Designing a business card may appear to be simple, but designing a good business card is a real challenge. Think of the necessary elements: the person's name, job title, company, the address, and other essentials. This list can get pretty long if phone, fax, e-mail, Website, and the lot are all included. You would think that this would leave room for little else. But look at the designs in this book: there is an abundance of graphics, colors, logos, and extra elements. None of them seem to be restricted or in any way held back by the text; all are successfully designed. This volume is a wonderful resource for everybody interested in business cards: designers and clients.

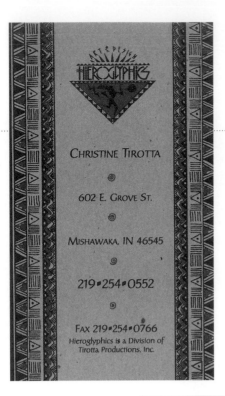

Tiffany Boren
Catering Manager
Sleeper Street Cafe

Telephone 617-563-9013 Fax 617-563-9013

1
DESIGN FIRM Stewart Monderer Design, Inc.
ART DIRECTOR Stewart Monderer
DESIGNER Felipe Del Corral
CLIENT Sebastian's Catering

2
DESIGN FIRM Greteman Group
DESIGNERS Sonia Greteman, James Strange
CLIENT Perfectly Round Productions
Video production

3
DESIGN FIRM The Bradford Lawton Design Group
ART DIRECTORS Brad Lawton, Jennifer Griffith-Garcia
DESIGNER Brad Lawton
CLIENT The Graphic Shop
Printing

Barbara Pyle
Board Member

Captain Planet Foundation

One CNN Center
Atlanta GA 30303
Phone 404 827 1918
Fax 404 827 4292
Internet: barbara.pyle@turner.com

Printed with vegetable based inks on 100% recycled paper

DESIGN FIRM Icehouse Design
ART DIRECTOR Pattie Belle Hastings
DESIGNER Bjorn Akselsen
ILLUSTRATOR Turner Broadcasting
System inhouse
CLIENT TBS
TOOLS Power Macintosh 8100
PAPER/PRINTING Benefit Natural Flax

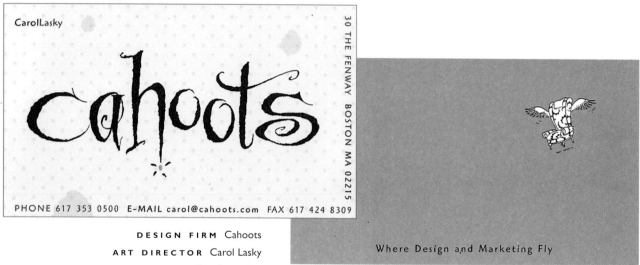

CarolLasky

cahoots

30 THE FENWAY BOSTON MA 02215

PHONE 617 353 0500 E-MAIL carol@cahoots.com FAX 617 424 8309

Where Design and Marketing Fly

DESIGN FIRM Cahoots
ART DIRECTOR Carol Lasky
DESIGNER Erin Donnellan
ILLUSTRATORS Bill Mayers, Mark Allen
CLIENT Cahoots
TOOLS Adobe Illustrator, QuarkXPress
PAPER/PRINTING Strathmore Elements/The Ink
Spot

DESIGN FIRM Fordesign
ALL DESIGN Frank Ford
TOOLS Adobe Illustrator, Macromedia
Fontographer, Macromedia FreeHand,
Adobe Photoshop
PAPER/PRINTING
Various papers/Aluminum printing plate

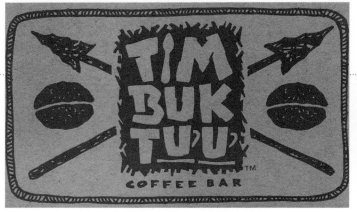

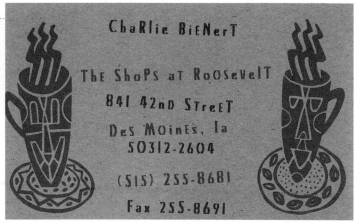

DESIGN FIRM Sayles Graphic Design
ALL DESIGN John Sayles
CLIENT Timbuktuu Coffee Bar
PAPER/PRINTING Cross Pointe Genesis copper/Offset

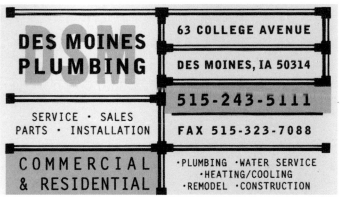

DESIGN FIRM Sayles Graphic Design
ALL DESIGN John Sayles
CLIENT Des Moines Plumbing
PAPER/PRINTING Neenah Classic Crest gray/Offset

DESIGN FIRM Duck Soup Graphics
ART DIRECTOR/DESIGNER William Doucette
CLIENT Lemmerick Marketing
TOOLS Macromedia FreeHand, QuarkXPress
PAPER/PRINTING Classic Columns/
Two match colors

Media-
Network

www.media-network.com

Rosanne Esposito
Executive Producer

rosanne@media-network.com
821 Sansome Street
San Francisco, CA 94111
v 415.283.1811 x1811
f 415.283.1801

Media-
Network

www.media-network.com

Cloude Porteus
IS Architect

cloude@media-network.com
821 Sansome Street
San Francisco, CA 94111
v 415.283.1811 x 1802
f 415.283.1801

Media-
Network

www.media-network.com

Hans Hartman
Executive Producer

hans@media-network.com
821 Sansome Street
San Francisco, CA 94111
v 415.283.1811 x 1888
f 415.283.1801

DESIGN FIRM Bruce Yelaska Design
ART DIRECTOR/DESIGNER Bruce Yelaska
CLIENT Media-Network
TOOLS Adobe Illustrator, Adobe Photoshop
PAPER/PRINTING Strathmore Writing/Offset

DESIGN FIRM S&N Design
ALL DESIGN Craig Goodman
CLIENT Chryalisis
TOOLS Adobe Illustrator
PAPER/PRINTING Neenah Classic Columns 120 lb.
cover/PMS 357, litho, matte copper foil

DESIGN FIRM Teikna
ART DIRECTOR/DESIGNER Claudia Neri
CLIENT Motion Pictures
TOOLS QuarkXPress, Adobe Photoshop
PAPER/PRINTING Arjowiggins/One color

1

DESIGN FIRM
Dean Johnson Design
ART DIRECTOR Scott Johnson
DESIGNER Scott Johnson
ILLUSTRATOR Scott Johnson
CLIENT Lewis & Associates

2

DESIGN FIRM Leslie Chan
Design Co., Ltd.
ART DIRECTOR Leslie Chan, Wing
Kei
DESIGNER Leslie Chan, Wing Kei,
Tong Song Wei
CLIENT Topline Communication Inc.

3

DESIGN FIRM
Sayles Graphic Design
CLIENT Sheree Clark

4

DESIGN FIRM The Riordon
Design Group Inc.
ART DIRECTOR Ric Riordon
DESIGNER Dan Wheaton
ILLUSTRATOR Bill Frampton
CLIENT The Riordon Design
Group Inc.

DESIGN FIRM Phoenix Creative
DESIGNER Ed Mantels-Seeker
CLIENT Simply Cruises
TOOLS QuarkXPress, Adobe Illustrator
PAPER/PRINTING Two-color litho with one color change

DESIGN FIRM MA&A—Mário Aurélio & Asscociados
ART DIRECTOR Mário Aurélio
DESIGNERS Mário Aurélio, Rosa Maia
CLIENT Prémaman

DESIGN FIRM Tower of Babel
DESIGNER Eric Stevens
CLIENT SP Masonry
TOOLS Macromedia FreeHand
PAPER/PRINTING Confetti Rust/Groves Printing

I

GREG COLEMAN
Director of Marketing
Tel. 612.339.5218

RETIREMENT AND ESTATE ADVISORS

1320 Metropolitan Centre Minneapolis, Minnesota Fax 612. 337.5070
333 South 7th Street Zip 55402

2

INVESTMENT
······ AGE ······
PUBLISHING

KATE LINDE
President

17008 Island View Drive
Huntersville, NC 28078
Telephone 704/896.9631

1

DESIGN FIRM Design Center
ART DIRECTOR John Reger
DESIGNER Sherwin Schwartzrock
CLIENT Retirement & Estate
Advisors Financial planning

2

DESIGN FIRM Mervil
Paylor Design
DESIGNER Mervil M. Paylor
CLIENT Investment Age Publishing
Investment texts publishing

3

DESIGN FIRM Robbins Design
DESIGNER Tom Robbins
CLIENT Steven C. O'Neal
Horticulture and landscape
architecture

4

DESIGN FIRM Design Center
ART DIRECTOR John Reger
DESIGNER Todd Spichke
CLIENT Wall Street Advisors
Financial planning

STEVEN C.
O·N·E·A·L, M.S.

O

Consultant

3500 CROSSTREE COURT

HORTICULTURE

COLUMBUS, OH 43221

& LANDSCAPE

(614) 777-1615

3

4

S.E. TARRAF

President

WALL STREET ADVISORS

950 Interchange Tower

600 South Hwy 169

Minneapolis, Mn 55426

Pho 612-546-5657

800-359-6078

Fax 612-546-5672

DESIGN FIRM Rick Eiber Design (RED)
ART DIRECTOR/DESIGNER Rick Eiber
CLIENT Lanie Riley
TOOLS Debossing Die
PAPER/PRINTING Two colors over one, watercolor crayon

DESIGN FIRM Charney Design
ALL DESIGN Carol Inez Charney
CLIENT Jeanie Maceri
TOOLS QuarkXPress, Adobe Photoshop
PAPER/PRINTING Vintage/Offset

DESIGN FIRM Jill Morrison Design
ALL DESIGN Jill Morrison
CLIENT A Show of Hands
TOOLS Adobe Photoshop, Macromedia
FreeHand, QuarkXPress
PAPER/PRINTING Two color

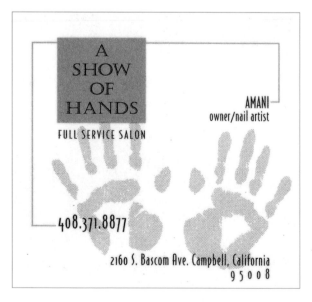

DESIGN FIRM
Fire House, Inc.
ART DIRECTOR/DESIGNER
Gregory R. Farmer
CLIENT
Twist Salon, Daphne Raider
TOOLS
QuarkXPress, Macromedia
FreeHand, Macintosh
PAPER/PRINTING
Schulze Printing

DESIGN FIRM Kanokwalee Design
ART DIRECTOR/DESIGNER Kanokwalee
Pusitanun
CLIENT Kanokwalee Design
TOOLS Adobe Illustrator, QuarkXPress
PAPER/PRINTING Speckletone/Kraft

DESIGN FIRM Transparent Office
ART DIRECTOR/DESIGNER Vibeke Nødskov
CLIENT Ventana Europe
TOOLS Adobe Illustrator, QuarkXPress
PAPER/PRINTING Copper Cromalux/Two color

DESIGN FIRM Mother Graphic Design
ART DIRECTOR/DESIGNER Kristin Thieme
ILLUSTRATOR Melinda Dudley
CLIENT RA Records

13

1

DESIGN FIRM Gibbs Baronet
ART DIRECTORS Steve Gibbs,
Willie Baronet
DESIGNER Steve Gibbs, Willie
Baronet, Kelly Kimball
CLIENT Self-promotion
Graphic design

2

DESIGN FIRM Hornall Anderson
Design Works
ART DIRECTOR Jack Anderson
DESIGNERS Jack Anderson,
Julie Keenan
ILLUSTRATOR George Tanagi
CLIENT Rod Ralston Photography

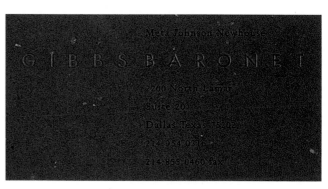

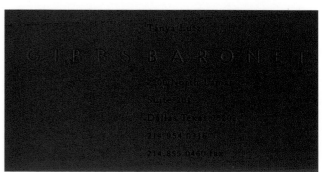

2

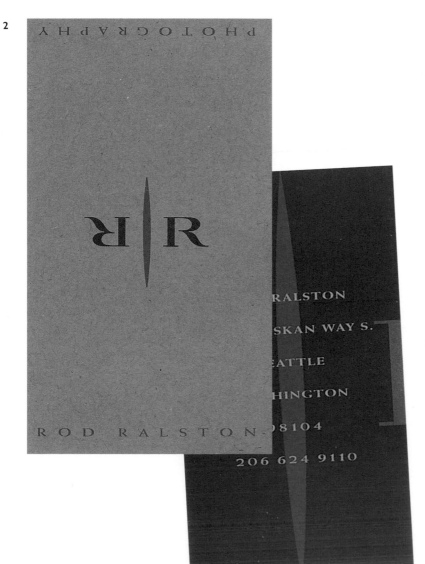

CAROL J. MCCUTCHEON

GENERAL, COSMETIC & FAMILY DENTIST

Dr. Carol

CAROL MCCUTCHEON, D.D.S, INC.
621 EAST CAMPBELL AVE. SUITE 18
CAMPBELL, CA 95008
408/379-0851 FAX 378-7515

BRUSH & FLOSS

OPEN SAYS ME!

HAVE AN IMPORTANT DATE WITH DR. CAROL!

ON

AT

FOR

CALL TO CONFIRM!
408/379-0851

EAST CAMPBELL AVE. SUITE 18 CAMPBELL, CA 95008

YOU HAVE AN IMPORTANT
DATE WITH DR. CAROL!

ON

AT

FOR

CALL TO CONFIRM! 408/379-0851

621 EAST CAMPBELL AVE. SUITE 18

CAMPBELL, CA 95008

IT'S A DATE!

DESIGN FIRM Aerial
ART DIRECTOR/DESIGNER Tracy Moon
CLIENT Carol J. McCutcheon, DDS
TOOLS QuarkXPress, Adobe Photoshop, Adobe Illustrator
PAPER/PRINTING Strathmore Bright White Dots

Romeo to get into **VROOM!** Nobody gets it about technology. People knowing more. People finding ...ut. People getting the message. People fixing the details. People acting in unison. People freeing ...reativity. People having the time **WHIRRR** Metatypographicon **TAPTAPPETYTAP** Your wrist is ...xhausted from all that pointing and clicking. Time for some stretching exercises: Converse. Reach ...rab. Lift. Tilt. Drink. Repeat **GLUB** Female hand reaches into view and with weary authority presses ...LAY **FWEEP?** "Be it declared for ever that I Bronwyn, wife of Idris of Hampstead, in return for the ...Miracle of my husband's life..." **CLANGG...** A player does a little victory jig to the congratulations of his ...iends. 'Apparently he has just saved their fantasy lives **KA-CHING!** The bad news is: money is ugly ...nchored in the past, hidebound by tradition, the money we scratch to get turns out to be insipid ...olorless, prosaic **WHOOSH!** Having obtained a mysterious Object in the Southern Outpost, the ...layers travel to Kalaman to have the Object deciphered by the Dream Merchant in Kalaman's ...amous open-air bazaar **WHIFF** Pansies, those infallible border brighteners, have a remarkable past ...Apothecarists clandestinely plucked them for love potions; Victorians extolled their virtues in art ...urkish perfumers harvested them by the ton **PLUCK** The joys of attempting and accomplishing are ...owerful currency **THUNK!** Head. Heart. Hands. / The tao of gardens / informs our work. / Nurture ...hape. Cultivat... ...cabinet door... ...riented **AHA!** ...eighbors, a'pa... ...remember, if y...

Ken Eklund Communications
526 Fuller Avenue San Jose CA 95125·1544
VOX *et* FAX 408·280·1441

SHAZAM!

3

JOSE LUIS RODRIGUEZ
·FOTOS·

AV. MITRE 4030
DPTOS. 2.4.5
1605 · VICENTE LOPEZ
TEL./FAX.: 756-4763

2

We at Redfeather Design are dedicated to building long-term relationships.

We are committed to providing quality products, information and support.

Our goal is that your Redfeather outdoor experience exceeds your expectations.

REDFEATHER
SNOWSHOES

Frank Federer

1280 Ute Ave., #20
Aspen, CO 81611
Tel 303 925·5333
1·800 525·0081
Fax 303 925·2311

4

PROSPECTS

Ann T. Harpole

Prospects for Fitness
9207 C U.S. Highway 42
Prospect, Kentucky 40059
(502) 228-8760

5

Cecilia España Diseñadora Gráfica

Av. Figueroa Alcorta 3086-8º

1425 Capital Federal

Teléfono y fax 807-6545

A B*c*D*e* F G H I J K L

206 · 525 · 1162

Richard Kehl

206 · 525 · 1162

Richard Kehl

DESIGN FIRM Rick Eiber Design (RED)

ART DIRECTOR/DESIGNER Rick Eiber

CLIENT Sam A. Angeloff

TOOLS Macintosh

PAPER/PRINTING Cougar/Four-color process over black

LYNN
WOOD
design

34 HAWTHORNE ROAD
WINDHAM, NH 03087
603-425-1883
FAX 603-437-1332
LNWDESIGN@AOL.COM

DESIGN FIRM Lynn Wood Design

ART DIRECTOR/DESIGNER Lynn Wood

CLIENT Floyd Johnson

TOOLS QuarkXPress, Adobe Illustrator

PAPER/PRINTING Benefit

DESIGN FIRM 9 Volt Visuals

ART DIRECTOR/DESIGNER Bobby June

CLIENT 23 Skateboards

TOOLS Adobe Illustrator

PAPER/PRINTING Twin Concepts

Lee Rodgers
PRINCIPAL, RETAIL SALES

ART CLASSICS LTD.

1490 Frontage Road
O'Fallon, IL 62269
618 224-9133 *Phone*
618 224-9059 *Fax*

DESIGN FIRM Phoenix Creative, St. Louis
ART DIRECTOR/DESIGNER
Ed Mantels-Seeker
ILLUSTRATORS Ed Mantels-Seeker, Ann Guillot
TOOLS Macromedia FreeHand
PAPER/PRINTING Four-color offset

DESIGN FIRM On The Edge
ART DIRECTOR Jeff Gasper
DESIGNER Gina Mims
CLIENT Sorrento Grille
TOOLS Adobe Illustrator,
QuarkXPress, Adobe Photoshop
PAPER/PRINTING Quest brown

DESIGN FIRM Jim Lange Design
ALL DESIGN Jim Lange
CLIENT Lee Langill
TOOLS Pen and ink

DESIGN FIRM M-DSIGN
ALL DESIGN Mika Ruusunen
CLIENT M-DSIGN
TOOLS Macintosh
PAPER/PRINTING Offset

ALIYA S. KHAN

graphic design & consulting

864.627.9065
aliya@viperlink.com
812 Gloucester Ferry Road
Greenville, SC 29607

DESIGN FIRM One, Graphic Design & Consulting
ART DIRECTOR/DESIGNER Aliya S. Khan
CLIENT One, Graphic Design & Consulting
TOOLS CorelDraw, PC
PAPER/PRINTING Neenah Paper
Classic Crest New Sawgrass

DESIGN FIRM Tharp Did It
ART DIRECTOR Rick Tharp
DESIGNERS
Rick Tharp, Amy Bednarek, Susan Craft
CLIENT Ladbrokes/London
TOOLS Macintosh
PAPER/PRINTING
Simpson Starwhite Vicksburg/Simon Printing

DESIGN FIRM Tower of Babel
DESIGNER Eric Stevens
CLIENT Tower of Babel
TOOLS Macromedia FreeHand
PAPER/PRINTING Groves Printing

Design Center

John C. Reger
President

15119 Minnetonka Boulevard
Minnetonka, MN 55345
USA
(612) 933 9766
Fax 933 1562

email: designcenter@dgi.net
http://www.dgi.net/designcenter

DESIGN FIRM Design Center
ART DIRECTOR John Reger
DESIGNER Dick Stanley
CLIENT Design Center
TOOLS Macintosh
PAPER/PRINTING Procraft Printing

DESIGN FIRM Animus Comunicaçáo
ART DIRECTOR Rique Nitzsche
DESIGNER Wiz Henrique Londres
CLIENT Yvonne Kossmann Demenezes
TOOLS Macromedia FreeHand, Adobe Photoshop
PAPER/PRINTING Opaline 180 gsm/Four color

DESIGN FIRM 9 Volt Visuals
ART DIRECTOR/DESIGNER Bobby June
PHOTOGRAPHER Jason Nadeau
CLIENT 9 Volt Visuals
TOOLS Adobe Photoshop, Adobe Illustrator
PAPER/PRINTING Twin Concepts

DESIGN FIRM Animus Comunicaçáo
ART DIRECTOR Rique Nitzsche
DESIGNER Victal Caesar
CLIENT Neisa Nitzsche Teixeira
TOOLS Macromedia FreeHand, Adobe Photoshop
PAPER/PRINTING Opaline 180 gsm/Four color

DESIGN FIRM
Di Luzio Diseño
ART DIRECTOR/DESIGNER
Hector Di Luzio
CLIENT
Venus Hotel
PAPER/PRINTING
Offset

DESIGN FIRM
Rick Eiber Design (RED)
ART DIRECTOR/DESIGN
Rick Eiber
CLIENT
Ron Rabin
TOOLS
Debossed with actual
photo print, each card in Gl. Env.
PAPER/PRINTING
Teton/Engraved

DESIGN FIRM
Steve Trapero Design
ART DIRECTOR/DESIGNER
Steve Trapero
CLIENT
Cal Pack
TOOLS
Adobe PageMaker, Adobe Illustrator
PAPER/PRINTING
House uncoated/Black ink

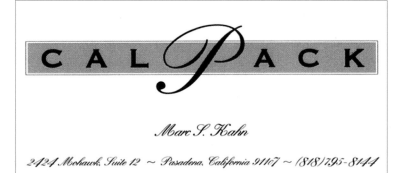

21

form fünf

Verbale und
visuelle
Kommunikation

Daniel Henry Bastian

Alexanderstraße 9B
28203 Bremen

Telefon
0421 782 26
Fax
0421 70 06 17
Isdn
0421 70 30 74

DESIGN FIRM Form 5
DESIGNERS Daniel Bastian,
Ulysses Voecker, Martin Veicht
CLIENT Form 5
TOOLS QuarkXPress, Macromedia
Fontographer, Adobe Photoshop, Stamp
PAPER/PRINTING Karten Karton

1

2

GRENE
CORNEA

MARK WELLEMEYER, M.D.

8020 East Central
Wichita, KS 67206
Tel 316-636-2010
Fax 316-636-5174
1-800-788-3060

3

Keller Groves, Inc.

Herman J. Keller
PRESIDENT

P.O. BOX 2468
WAUCHULA
FLORIDA, 33873
813.773.9411

TUMBLE DRUM.sm

JACQUELINE SWARTZ

Mid-Rivers Plaza
5849 Suemandy Drive
St. Peters, Missouri 63376
Tel 314-397-7700

4

Donna Hall

Consultant

104 Randi Drive

Madison, CT 06443

tel 20

fax 20

H
DONNA HALL

1

DESIGN FIRM Greteman Group
DESIGNERS
Sonia Greteman, Bill Gardner, James Strange
CLIENT Tumble Drum
Children's recreational center

2

DESIGN FIRM Greteman Group
DESIGNER Sonia Greteman
CLIENT Grene Cornea
Cornea, cataract, and refractive surgery

3

DESIGN FIRM JOED Design, Inc.
DESIGNER Edward Rebek
CLIENT Herman Keller
Orange grower

4

DESIGN FIRM Greteman Group
DESIGNERS James Strange,
Sonia Greteman
CLIENT Donna Hall
Health care consultant

5

DESIGN FIRM Eat Design
ART DIRECTOR Patrice Eilts-Jobe
DESIGNERS Patrice Eilts-Jobe,
Kevin Tracy
ILLUSTRATOR Kevin Tracy
CLIENT St. Paul's Episcopal Day School

5

ST·PAUL'S
EPISCOPAL
DAY SCHOOL

KAREN MONSEES
DIRECTOR OF ADMISSIONS

4041 MAIN STREET
KANSAS CITY, MO 64111
SCHOOL OFFICE 816-931-8614
SCHOOL FAX 816-931-6860

1

THERESA GRAY

CRAIG & COMPANY

3609A GREENVILLE
DALLAS, TX 75206
214 821-5299
HAIR
NAILS
MAKEUP

2

7808 CREEKRIDGE CIRCLE STE #315
MINNEAPOLIS, MN 55439
FACSIMILE 612.946.1102

GLOBAL ACCESS INC.

JAMES W. MAY
OWNER
PHONE 612.946.1064

1

DESIGN FIRM Sullivan Perkins
DESIGNER Art Garcia
CLIENT Craig & Company
Hair salon

2

DESIGN FIRM Design Center
ART DIRECTOR John Reger
DESIGNER Sherwin Swartzrock
CLIENT Global Access
International consulting

3

DESIGN FIRM Fullmoon
Creations, Inc.
ART DIRECTOR Frederic Leleu
DESIGNER Lisa Leleu
ILLUSTRATOR Lisa Leleu
CLIENT Hankins & Associates
Kitchen and bath design

4

DESIGN FIRM Associates Design
DESIGNER Jill Arena
CLIENT Graziano's Restaurant

5

DESIGN FIRM Karen Barranco
Design & Illustration
DESIGNER Karen Barranco
CLIENT Marshall Vernet
Locations scout

3

HANKINS & ASSOCIATES

Jerome Hankins

KITCHEN & BATH DESIGN
P.O. Box 113 · Doylestown, Pa. 18901 · Tel: 215-794-5930 · Fax: 215-794-5931

4

GrAZiaNo's
BRICK OVEN PIZZA

5960 WEST TOUHY AVENUE
NILES, ILLINOIS 60714
708·647·4096 FAX 708·647·4097

5

MARSHALL VERNET LOCATIONS

213 938 2919

DESIGN FIRM Fire House, Inc.
ART DIRECTOR/DESIGNER Gregory R. Farmer
CLIENT Creatures of Habit
TOOLS QuarkXPress, Adobe Photoshop, Macintosh
PAPER/PRINTING Moore Laugen Printing Co.

DESIGN FIRM
Hieroglyphics Art & Design
DESIGNER/ILLUSTRATOR
Christine Osborn Tirotta
PHOTOGRAPHER
John Tirotta
CLIENT
Tirotta Photo Productions
PAPER/PRINTING
Starwhite Vicksburg UV Ultra II

JACK CODY &
NATALYA HADEN
OWNERS

creatures

• COSTUME RENTAL
• ANTIQUES
• VINTAGE CLOTHING

of habit

406 BROADWAY
PADUCAH, KY 42001
502.442.2923

DESIGN FIRM Jeff Fisher Logomotives
ALL DESIGN Jeff Fisher
CLIENT Barrett Rudich, Photographer
TOOLS Macromedia FreeHand
PAPER/PRINTING Fine Arts Graphics

DESIGN FIRM MC
Studio/Times Mirror Magazines
ART DIRECTOR Paul Kelly
DESIGNERS Kirsten Heincke,
Paul Kelly
CLIENT Self-promotion
Graphic design

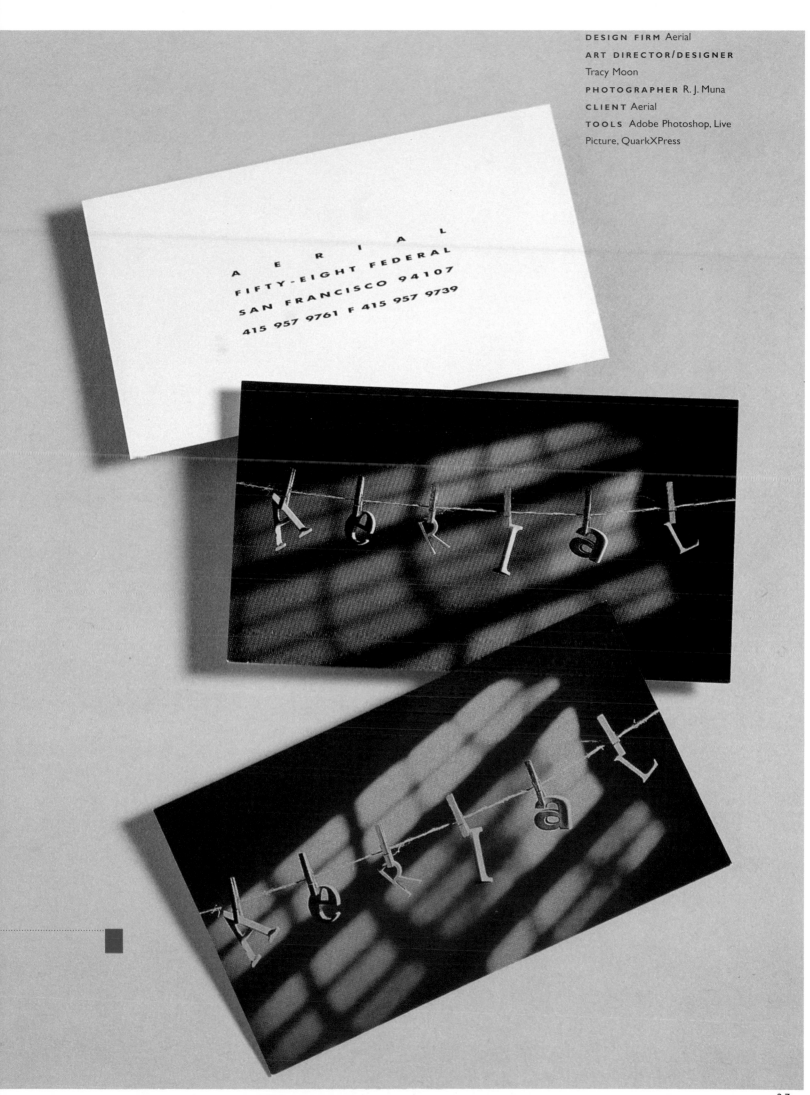

DESIGN FIRM Aerial
ART DIRECTOR/DESIGNER
Tracy Moon
PHOTOGRAPHER R. J. Muna
CLIENT Aerial
TOOLS Adobe Photoshop, Live
Picture, QuarkXPress

1

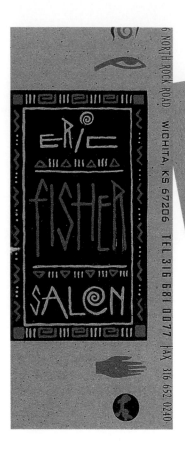

3

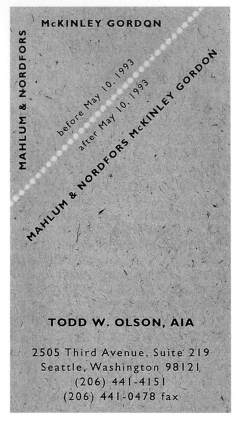

2

4

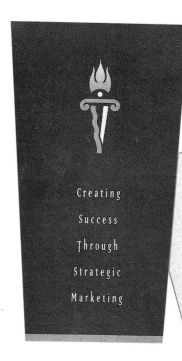

Creating

Success

Through

Strategic

Marketing

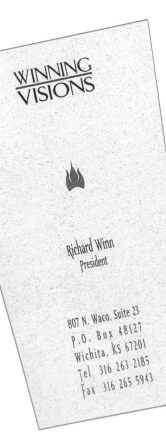

WINNING VISIONS

Richard Winn
President

807 N. Waco, Suite 23
P.O. Box 48127
Wichita, KS 67201
Tel 316 263 2185
Fax 316 265 5943

1

DESIGN FIRM
Greteman Group
DESIGNERS Sonia
Greteman, Bill Gardner
CLIENT Eric Fisher Salon
Hair sylist

2

DESIGN FIRM Mervil
Paylor Design
ART DIRECTOR
Mervil M. Paylor
DESIGNERS Mervil M.
Paylor, Brady Bone
ILLUSTRATOR
Gary Palmer
CLIENT
Pasta & Provisions
Pasta, wine and sauce retail

3

DESIGN FIRM
Hornall Anderson
Design Works
ART DIRECTOR
Jack Anderson
DESIGNERS
Jack Anderson, Scott Eggers,
Leo Raymundo
CLIENT Mahlum &
Nordfors McKinley Gordon
Architecture

4

DESIGN FIRM Greteman
Group
ART DIRECTOR
Sonia Greteman
DESIGNERS Sonia
Greteman, Jo Quillin
CLIENT Winning Visions
Strategic marketing

DESIGN FIRM
Kan & Lau Design Consultants
ART DIRECTOR/DESIGNER
Freeman Lau Siu Hong
CLIENT
Freeman Lau Siu Hong
PAPER/PRINTING
Conqueror Diamond White
250 gsm/Offset

1336 East Douglas

Wichita, KS 67214

Tel 316-263-5750

Fax 316-269-3574

1-800-466-5750

DESIGN FIRM
Greteman Group
ART DIRECTORS/DESIGNERS
Sonia Greteman, James Strange
ILLUSTRATORS
James Strange, Sonia Greteman
CLIENT
Furniture Options
PAPER/PRINTING
Speckletone/Offset

DESIGN FIRM Stephen Peringer Illustration
DESIGNER/ILLUSTRATOR Stephen Peringer
CLIENT Paul Mader/DreamWorks
TOOLS Adobe Photoshop, pen, ink
PAPER/PRINTING LaValle Printing

4557 46TH AVENUE N.E.
SEATTLE, WASHINGTON 98105

VOICE: 206.527.8286
FAX: 206.524.6641

CARY PILLO LASSEN
ILLUSTRATOR

4557 46TH AVENUE N.E.
SEATTLE, WASHINGTON 98105

VOICE: 206.527.8286
FAX: 206.524.6641

CARY PILLO LASSEN
ILLUSTRATOR

4557 46TH AVENUE N.E.
SEATTLE, WASHINGTON 98105

VOICE: 206.527.8286
FAX: 206.524.6641

CARY PILLO LASSEN
ILLUSTRATOR

4557 46TH AVENUE N.E.
SEATTLE, WASHINGTON 98105

VOICE: 206.527.8286
FAX: 206.524.6641

CARY PILLO LASSEN
ILLUSTRATOR

DESIGN FIRM
Belyea Design Alliance
ART DIRECTOR
Patricia Belyea
DESIGNER
Tim Ruszel
ILLUSTRATOR
Cary Pillo Lassen
CLIENT
Cary Pillo Lassen

L E N O X
R O O M

1278 THIRD AVENUE NEW YORK CITY 10021

TEL 212.772.0404 FAX 212.772.3229

L E N O X
R O O M

1278 THIRD AVENUE NEW YORK CITY 10021

TEL 212.772.0404 FAX 212.772.3229

TIP WELL AND PROSPER

L E N O X
R O O M

1278 THIRD AVENUE NEW YORK CITY 10021

TEL 212.772.0404 FAX 212.772.3229

L E N O X
R O O M

CHARLIE PALMER

1278 THIRD AVENUE NEW YORK CITY 10021

TEL 212.772.0404 FAX 212.772.3229

WWW.LENOXROOM.COM

DESIGN FIRM Aerial
ART DIRECTOR/DESIGNER Tracy Moon
PHOTOGRAPHER R. J. Muna
CLIENT Lenox Room Restaurant
TOOLS Adobe Photoshop, QuarkXPress

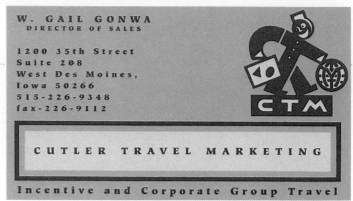

DESIGN FIRM Sayles Graphic Design
ALL DESIGN John Sayles
CLIENT Cutler Travel Marketing
PAPER/PRINTING Curtis Brightwater riblaid slate/Offset

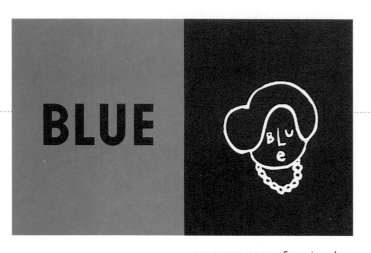

DESIGN FIRM Sagmeister, Inc.
ART DIRECTOR Stefan Sagmeister
DESIGNERS Stefan Sagmeister, Eric Zim
ILLUSTRATOR Stefan Sagmeister
CLIENT Blue Fashion Retail
PAPER/PRINTING Strathmore Writing 25% cotton

You spoke to:

Name

BLUE Clothing in Feldkirch:
Marktgasse 13, A-6800 Feldkirch, Austria

Please call us at: 05522 73 722-0
When abroad, dial: 43 5522 73 722-0

YES! We do speak German.

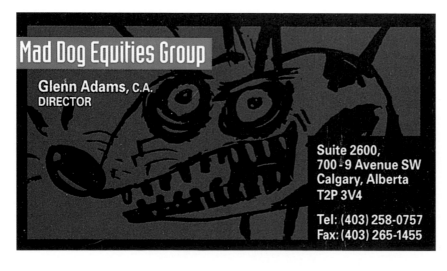

DESIGN FIRM Black Letter Design, Inc.
ART DIRECTOR/DESIGNER Ken Bessie
ILLUSTRATOR Rick Sealock
CLIENT Mad Dog Equities Group
TOOLS Adobe Illustrator, QuarkXPress
PAPER/PRINTING Expression Iceberg/Offset

1

2

3

1

DESIGN FIRM Phoenix Creative
DESIGNER Eric Thoelke
CLIENT Accentrix
High-end furniture and antique retail

2

DESIGN FIRM Design
Management Group
ART DIRECTOR Kevin Bird
DESIGNER Kevin Bird
CLIENT Self-promotion
Communications counseling,
design, and writing

3

DESIGN FIRM Greteman Group
DESIGNERS Sonia Greteman,
James Strange
CLIENT Motorworks by Autocraf
Auto repair

4

DESIGN FIRM THARP DID IT
ART DIRECTOR Rick Tharp
DESIGNERS Laurie Okamura,
Colleen Sullivan, Rick Tharp
ILLUSTRATOR Georgia Deaver
CLIENT Integrated Media Group
Multi-media educational materials

4

1

2

1

DESIGN FIRM Animus
Comunicaçáo
ART DIRECTOR Rique Nitzsche
DESIGNER Rique Nitzsche,
Felício Torres
CLIENT Less Money
Shoe retail

2

DESIGN FIRM One & One
Design Consultants Inc.
DESIGNER Dominick Sarica
CLIENT AMS Woodcrafts
Woodworking

3

DESIGN FIRM Maximum
ART DIRECTOR Ed Han
DESIGNER Deirdre Boland
ILLUSTRATOR Deirdre Boland
CLIENT The Chicago
Bicycle Company
Hand-crafted bike manufacturing

4

DESIGN FIRM Blink
DESIGNER Scott Idleman
CLIENT Self-promotion
Graphic design

3

Barbara Wallich
Account Coordinator

250 Ridge Road
Post Office Box 558
Dayton, New Jersey
Zip 08810.0558
Voice 908.274.2000
Fax 908.274.2417

Heather Caruso
Graphics Coordinator

250 Ridge Road
Post Office Box 558
Dayton, New Jersey
Zip 08810.0558
Voice 908.274.2000
Fax 908.274.2417

Joseph DeAmbrose
Designer

250 Ridge Road
Post Office Box 558
Dayton, New Jersey
Zip 08810.0558
Voice 908.274.2000
Fax 908.274.2417

DESIGN FIRM Aerial
ART DIRECTOR/DESIGNER Tracy Moon
CLIENT Impact
TOOLS Adobe Illustrator, QuarkXPress

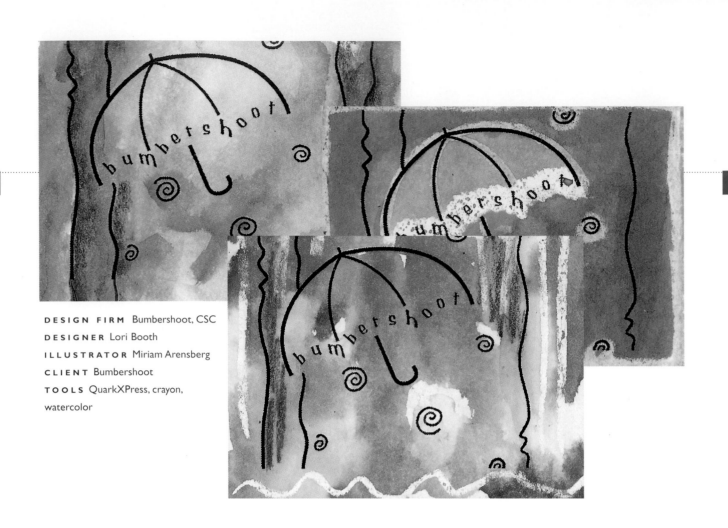

DESIGN FIRM Bumbershoot, CSC
DESIGNER Lori Booth
ILLUSTRATOR Miriam Arensberg
CLIENT Bumbershoot
TOOLS QuarkXPress, crayon,
watercolor

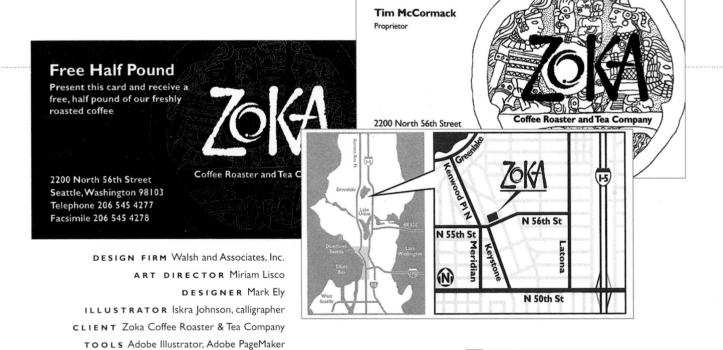

DESIGN FIRM Walsh and Associates, Inc.
ART DIRECTOR Miriam Lisco
DESIGNER Mark Ely
ILLUSTRATOR Iskra Johnson, calligrapher
CLIENT Zoka Coffee Roaster & Tea Company
TOOLS Adobe Illustrator, Adobe PageMaker
PAPER/PRINTING Classic Crest/Printercraft
Printing, two color

1

DESIGN FIRM
Dean Johnson Design
ALL DESIGN Scott Johnson
CLIENT Market Square Arena

2

DESIGN FIRM Platinum Design
ART DIRECTOR Victoria Peslak
DESIGNERS Sandy Quinn,
Kathleen Phelps
CLIENT Arte Salon

3

DESIGN FIRM
Dean Johnson Design
ALL DESIGN
Scott Johnson
CLIENT
Central Indiana Power

4

DESIGN FIRM
Dean Johnson Design
ALL DESIGN
Scott Johnson
CLIENT
World Rowing Championships

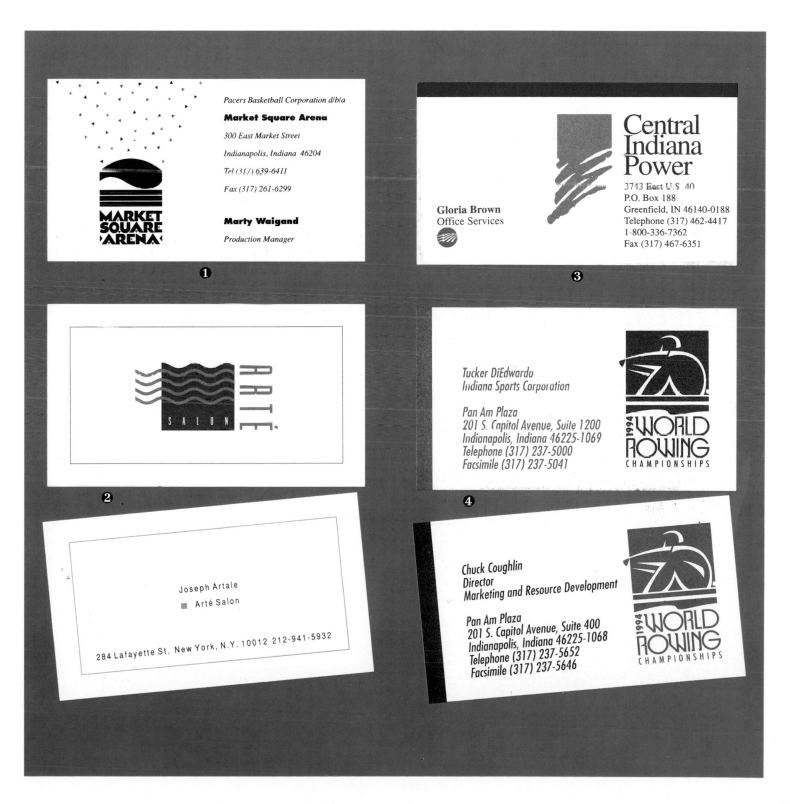

29140 Buckingham Ave. Suite 5

Livonia, MI 48154

313 261-2001

Fax: 313 261-3282

email: epicnode@aol.com

12330 Conway Road

St. Louis, MO 63141

314 205-2266

Fax: 314 205-2540

National Outreach

Corbett Heimburger

National Outreach Director

Evangelical Presbyterian Church

DESIGN FIRM Jacque Consulting & Design
DESIGNER/ILLUSTRATOR Janelle Sayegh
CLIENT Evangelical Presbyterian Church
TOOLS Adobe FreeHand
PAPER/PRINTING Neenah Classic Crest

DESIGN FIRM 9 Volt Visuals
ART DIRECTOR/DESIGNER Bobby June
CLIENT 9 Volt Visuals
TOOLS Adobe Photoshop, Adobe Illustrator
PAPER/PRINTING Twin Concepts

DESIGN FIRM Elena Design
ART DIRECTOR/DESIGNER Elena Baca
CLIENT Wendy Thomas
TOOLS Adobe Photoshop, QuarkXPress
PAPER/PRINTING French Speckeltone

DESIGN FIRM Duck Soup Graphics
ART DIRECTOR/DESIGNER William Doucette
CLIENT Sunbaked Software
TOOLS Macromedia FreeHand, QuarkXPress
PAPER/PRINTING Circa select/
Two match colors, blowtorch

1

JIM COX
ACOUSTIC AND ELECTRIC BASS
PRIVATE PARTIES • MUSIC CONSULTATION

PHONE 708.329.1213

2

Andrew Greenberg • 5454 Broadway • Oakland, CA 94618 • Fax 510 420 1574

Greenberg Qualitative Research • 510 420 1514

3

the herrington

CINDY PEPPLE
ASSISTANT HOTEL MANAGER

15 SOUTH RIVER LANE
GENEVA, ILLINOIS 60134
708·208·7433

4

DESIGN • ILLUSTRATION

Michael Lenn

mi'sha

1638 Commonwealth Av. • Suite 24 • Boston, MA 02135 • Tel. 617.277.7765 • Fax 617.277.3538

1

DESIGN FIRM JOED
Design Inc.
DESIGNER Joanne Rebek
CLIENT Jim Cox
Musician

2

DESIGN FIRM Stowe
Designer
DESIGNER Jodie Stowe
CLIENT Greenberg
Qualitative Research

3

DESIGN FIRM
Associates Design
DESIGNER Jill Arena
CLIENT The Herrington
Bed and breakfast

4

DESIGN FIRM Misha Design
DESIGNER Michael Lenn
CLIENT Self-promotion
Design and illustration

1

John D. Beckelhymer del Valle
President

WORLD-WIDE ASSET LOCATORS, INC.

1319 Rosario Street
Laredo, Texas 78040-8838
U.S.A.
512.727.3743
fax 512.791.2264

2

MACCO *Systems*

medical & dental
practice management systems

amar patel

457 W. ALLEN AVE. *suite* 117 SAN DIMAS. CA. 91773
fon 909.394.7288 *fax* 909.394.7290

MACCO *Systems*

3

THE GARRETT
HOTEL GROUP

DAVID W. GARRETT
President

166 BATTERY STREET
BURLINGTON, VERMONT 05401
802-865-0053 802-865-3146 FAX

1 DESIGN FIRM
Marc English Design
DESIGNER Marc English
CLIENT World-Wide Asset
Locators, Inc.
Purchasing brokerage

2 DESIGN FIRM
Jeff Labbé Design 0950
DESIGNER Jeff Labbé
CLIENT Macco Systems
Medical software development

3 DESIGN FIRM
Kaiser Dicken
ART DIRECTOR Craig Dicken
DESIGNER Debra Kaiser
CLIENT The Garrett Hotel Group
Exclusive hotel developers

4 DESIGN FIRM
Vaughn Wedeen Creative
DESIGNER Steve Wedeen
CLIENT Juniper Learning
Educational and teacher's aids

5 DESIGN FIRM
THARP DID IT
ART DIRECTOR Rick Tharp
DESIGNERS Jana Heer,
Rick Tharp
CLIENT Ken Benjamin
Wildlife photography

5

N

KEN BENJAMIN
PHOTOGRAPHER

211 Alexander Avenue • Los Gatos, CA 95030 • 408·354·8626

4

KATHY L. JAHNER

Juniper Learning

POST OFFICE DRAWER O · ESPAÑOLA, NEW MEXICO 87532
TEL 505.753.7410 · TOLL FREE 800.456.1776
FAX 505.747.1107

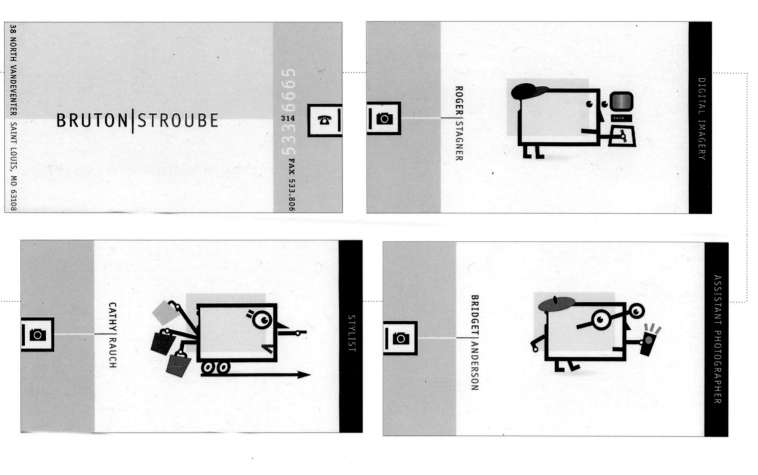

DESIGN FIRM Phoenix Creative
ART DIRECTOR/DESIGNER Eric Thoelke
ILLUSTRATORS Eric Thoelke, Kathy Wilkinson
CLIENT Bruton/Stroube Studios
TOOLS QuarkXPress
PAPER/PRINTING Strathmore/Six PMS, two sides

Mark D. Emerson
President

2910 Stevens Creek Blvd.
Suite 109-1845
San Jose, CA 95128-2015
voice mail 408-599-0816
ph 408-972-9103 fx 408-226-9324

DESIGN FIRM
JWK Design Group, Inc.
ALL DESIGN Jennifer Kompolt
CLIENT Maternal Concepts Ltd.
TOOLS Adobe Illustrator
PAPER/PRINTING Simpson
Evergreen Script Aspen

THOMAS SUZUKI, O.D.

DESIGN FIRM Design Source
ALL DESIGN Cari Johnson
CLIENT Dr. Thomas Suzuki
TOOLS Adobe Illustrator
PAPER/PRINTING Karma
Natural/Two-color offset

53 ASPEN WAY
WATSONVILLE, CA 95076
PHONE 408 724-1097
FAX 408 724-6364

11272 MERRITT ST., SUITE D
CASTROVILLE, CA 95012
408 633-0550

DESIGN FIRM Stefan Dziallas Design
DESIGNER/ILLUSTRATOR Stefan Dziallas
CLIENT Stefan Dziallas
TOOLS Adobe Photoshop, QuarkXPress, Macintosh
PAPER/PRINTING 300gsm Matt/Schneidersöhne

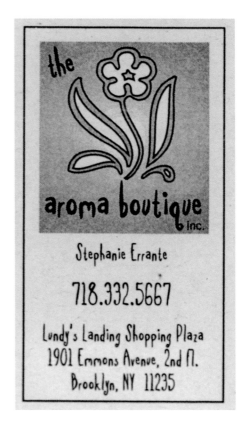

DESIGN FIRM Apple Graphics &
Advertising of Merrick, Inc.
DESIGNER Allison Blair Schneider
CLIENT The Aroma Boutique
TOOLS Macromedia FreeHand,
Power Macintosh 7500
PAPER/PRINTING Fox River Circa Select
Moss/One-color themography

1
DESIGN FIRM Toto Images, Inc.
ART DIRECTOR/DESIGNER
Andy H. Lun
CLIENT Factory Limited

2
DESIGN FIRM
McMonigle & Spooner
DESIGNER Jamie McMonigle
CLIENT Ocean States Network

3
DESIGN FIRM
Sayles Graphic Design
ALL DESIGN John Sayles
CLIENT Beckley Imports

4
ALL DESIGN Daniel Gonzalez
CLIENT Daniel Gonzalez

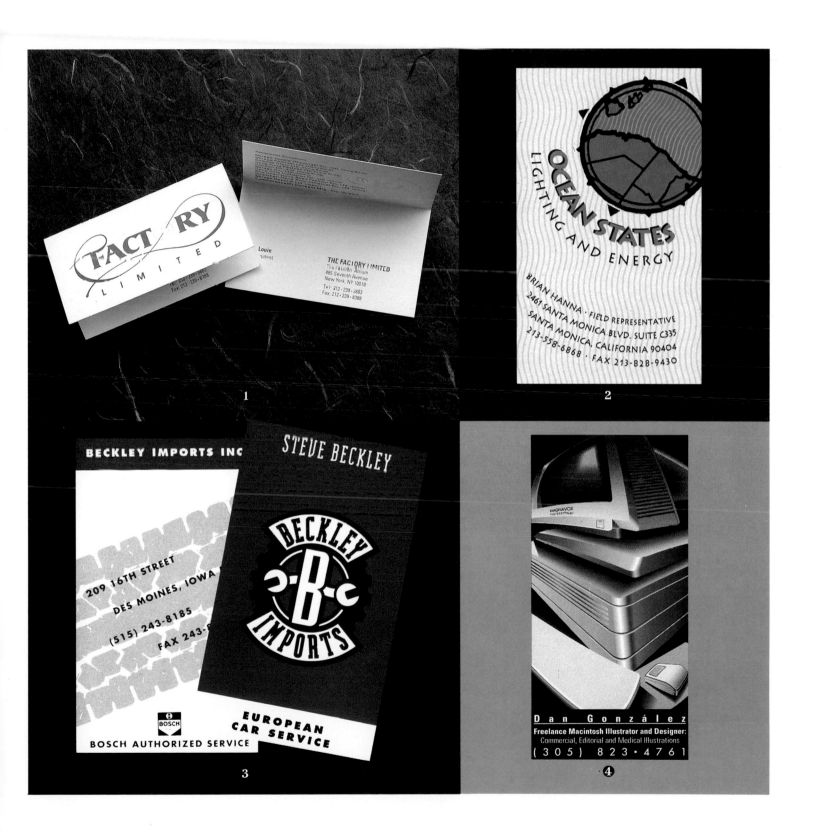

PAPER P O W E R
53 WARWICK ROAD, EALING, LONDON W5 5PZ
TEL 0181 579 6631 FAX 0181 840 1990

Lyn Hourahine FCSD

CHARTERED PAPER PRODUCT DESIGNERS
CREATIVE PAPER ENGINEERING DESIGN

PAPER P O W E R
53 WARWICK ROAD, EALING, LONDON W5 5PZ
TEL 0181 579 6631 FAX 0181 840 1990

Lyn Houranine FCSD

CHARTERED PAPER PRODUCT DESIGNERS
CREATIVE PAPER ENGINEERING DESIGN

DESIGN FIRM Paper Power
ART DIRECTOR/DESIGNER
Lyn Hourahine
DESIGNER Sherwin Schwartzrock
CLIENT Paper Power
TOOLS Macintosh

1

1
DESIGN FIRM Michael Courtney Design
DESIGNER Michael Courtney
ILLUSTRATORS Michael Courtney,
Nita Williamson, Donna Baxter
CLIENT Williamson Associates
Landscape architecture

2
DESIGN FIRM Marc English Design
DESIGNER Marc English
CLIENT Swept Away
Cleaning services

Sandy Williamson

(206) 784-7996
1737 NW 56th St.
Suite 101
Seattle, WA 98107
Fax 784-1264

Williamson Landscape
Architecture, LLC

WILLIAL055BF

WILLIAMSON
LANDSCAPE
ARCHITECTURE
Design & Construction

2

CLEANING SERVICES

SWEPT AWAY

CHRISTINE BLOMQUIST

49 PLEASANT STREET
EPPING, NEW HAMPSHIRE
03042
TELEPHONE (603) 679-2989

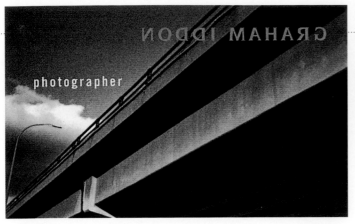

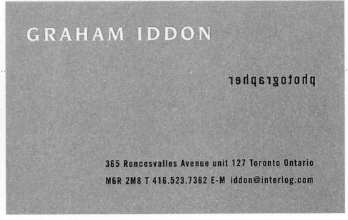

365 Roncesvalles Avenue unit 127 Toronto Ontario
M6R 2M8 T 416.523.7362 E-M iddon@interlog.com

DESIGN FIRM Teikna
ART DIRECTOR/DESIGNER Claudia Neri
PHOTOGRAPHER Graham Iddon
CLIENT Graham Iddon
TOOLS QuarkXPress
PAPER/PRINTING Strathmore Elements/Two color

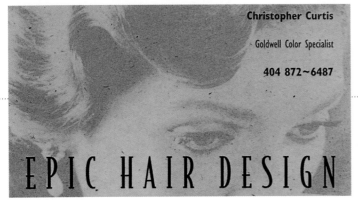

DESIGN FIRM The Design Company
ART DIRECTOR Marcia Romanuck
CLIENT Epic Hair Design
PAPER/PRINTING Fraser Genesis Dawn 80 lb. cover

DESIGN FIRM Communication Arts Company
ART DIRECTOR/DESIGNER Mary Kitchens
ILLUSTRATOR Cathy Kitchens
CLIENT Creations by Cathy
TOOLS Calligraphy, pen, ink, Macintosh
PAPER/PRINTING Offset lithography

Joel Morgenstern

444 Columbus Avenue
San Francisco, CA 94133

Tel: 415.433.9111
Fax: 415.362.6292

Email: HotelBoheme@
MCIMail.com

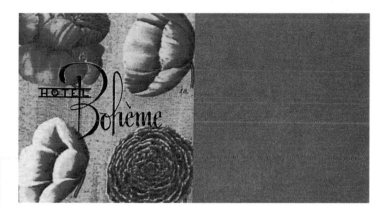

DESIGN FIRM Aerial
ART DIRECTOR/DESIGNER Tracy Moon
ILLUSTRATOR John Mattos (logotype)
PHOTOGRAPHERS Jerry Stoll, R. J. Muna
CLIENT Hotel Bohème
TOOLS Adobe Photoshop, QuarkXPress

1

DESIGN FIRM Design Center
ART DIRECTOR John Reger
DESIGNER Sherwin Schwartzrock
CLIENT St. Croix Sensory
Sensory laboratory

2

DESIGN FIRM Isheo Design House
DESIGNER Ishmael Sheo
CLIENT DOC - Sports Apparel
Sporting goods company

3

DESIGN FIRM Gerald Geffert
DESIGNER Gerald Geffert
CLIENT Teekampagne
Tea mail-order distribution

4

DESIGN FIRM IS Design
DESIGNER E-lan Ronen
CLIENT Self-promotion
Typography

5

DESIGN FIRM Design Center
ART DIRECTOR John Reger
DESIGNER Sherwin Schwartzrock
CLIENT McGinley Associates
Engineering consulting

1

St. Croix Sensory, Inc.

Charles M. McGinley, P.E.
Technical Director
612-439-0177

13701-30th Str. Circle N.
Stillwater, Minnesota 55082
Toll Free 800-879-9231
Fax 612-439-1065

2

Alicia Sonja
Store Manager

sports DOC apparel

AN AUSTRALIAN ORIGINAL

A Sports Station Division

Lot 45, Medianway,
Oak Street,
Fullerton, SA 5063,
Australia
Tel: 2779903
Fax: 2779905

3

Projektwerkstatt
Teekampagne
Patschkauer Weg 5
14195 Berlin
Telefon 030/8 59 10 13
030/8 59 10 14
Fax 030/8 59 10 21

DESIGN FIRM Widmeyer Design
ART DIRECTORS Ken Widmeyer,
Dale Hart
DESIGNER/ILLUSTRATOR
Dale Hart
CLIENT Rolling Cones
PAPER/PRINTING Mead paper/Offset

TEEKAMPAGNE

Thomas Fullroth

4

E·Y
Lettering Artist
Graphic Designer
718.544.4450

E - L A N R O N E N

5

MCGINLEY ASSOCIATES, P.A.

Charles M. McGinley, P.E.
Consulting Engineer
Pho. 612.439.1708
13701-30th Street Circle North
Stillwater, Minnesota 55082
Pho. 612.439.1708 Fax 439.1065

FEATURING
BEN&JERRY'S
PEACE POPS

RollingCones

Andy Davidson
117 EAST LOUISA STREET
SUITE NUMBER 315
SEATTLE, WA 98102
Phone 206.527.8388

DESIGN FIRM Widmeyer Design
ART DIRECTORS Dale Hart, Tony Secolo
DESIGNER Tony Secolo
ILLUSTRATOR Misha Melikov
CLIENT The Production Network
TOOLS Power Macintosh, Macromedia FreeHand
PAPER/PRINTING UV Ultra/Offset

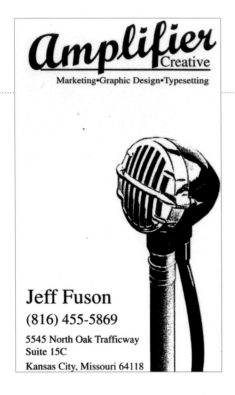

DESIGN FIRM Amplifier Creative
DESIGNER/ILLUSTRATOR Jeff Fuson
CLIENT Amplifier Creative
TOOLS Adobe Photoshop
PAPER/PRINTING Four-color process

DESIGN FIRM Multimedia Asia
ART DIRECTOR G. Lee
ILLUSTRATOR J. E. Jesus
CLIENT Multimedia Asia
TOOLS PageMaker
PAPER/PRINTING Milkweed
Genesis 80 lb./Four-color process

HIROKO TANAKA
One Irving Place U-12b
New York, NY 10003
Tel 212·995·8489 Fax 212·254·8233

DESIGN FIRM Mirko Ilić Corp.
ART DIRECTOR/DESIGNER Nicky Lindeman
CLIENT Mirko Ilić Corp.
TOOLS QuarkXPress
PAPER/PRINTING Cougar Smooth white
80 lb. cover/Rob-Win Press

DESIGN FIRM
Carl Chiocca Creative Designs
ALL DESIGN
Carl Chiocca
TOOLS
Adobe Photoshop, QuarkXPress
PAPER/PRINTING
Lustro Gloss 80 lb. cover/
Two color offset

CARL CHIOCCA
CREATIVE DESIGNS
& PRINT PRODUCTION

10 renwick street pittsburgh pa 15210

PHONE 412 431·2095 FACSIMILE 412 431·7750

DESIGN FIRM M-DSIGN
ALL DESIGN Mika Ruusunen
CLIENT M-DSIGN
TOOLS Macintosh
PAPER/PRINTING Offset

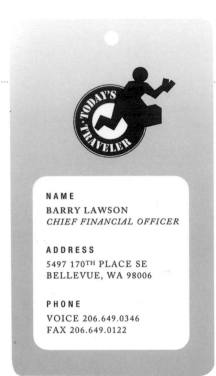

NAME
BARRY LAWSON
CHIEF FINANCIAL OFFICER

ADDRESS
5497 170TH PLACE SE
BELLEVUE, WA 98006

PHONE
VOICE 206.649.0346
FAX 206.649.0122

TICKETING

TOURS & CRUISES

PASSPORT & CURRENCY SERVICES

TRAVEL BOOKS, GUIDES & VIDEOS

LUGGAGE & ACCESSORIES

BON VOYAGE BASKETS

ON-LINE INFORMATION

GIFT CERTIFICATES

DESIGN FIRM Rick Eiber Design (RED)
ALL DESIGN Rick Eiber
CLIENT Today's Traveler
PAPER/PRINTING Three-colors,
over two-colors offset

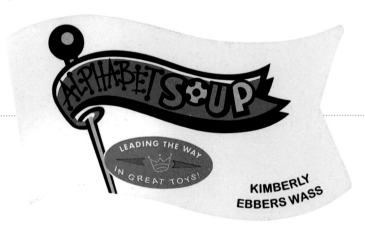

DESIGN FIRM Sayles Graphic Design
ALL DESIGN John Sayles
CLIENT Alphabet Soup
PAPER/PRINTING Neenah Environment
white wove, double cover/Offset

Planet Comics

Smith Haven Mall, Space E-15

Middle Country Road

Lake Grove, New York 11755

516-724-4096

John A. Gagliardi, CEO

DESIGN FIRM Kiku Obata & Company
ART DIRECTOR/DESIGNER Rich Nelson
CLIENT Planet Comics

1

PETERSON BLYTH PEARSON

216 EAST 45TH STREET

NEW YORK NY 10017 3374

212 557-5566

FAX 212 818-0627

RONALD A. PETERSON

MANAGING PARTNER

2

C O R B I S

Corbis Media | 15395 | 206/641-4505
| SE 30th Place | 800/260-0444
| Suite 300 |
| Bellevue | kaszm@corbis.com
Kasz Maciag | Washington |
Manager of Operations | 98007 | Fax 206/643-9740

TRISH NEAL-WILSON

3

MICHAEL WILSON

ARCHITECTURAL

PHOTOGRAPHY

1

DESIGN FIRM
Peterson Blyth Pearson
ART DIRECTOR
Ronald A. Peterson
DESIGNER Alex
Pennington
CLIENT Self-promotion
Design

2

DESIGN FIRM
Karyl Klopp Design
DESIGNER Karyl Klopp
CLIENT Arturo
Holistic counseling

3

DESIGN FIRM
David Carter Design
ART DIRECTOR Randall Hill
DESIGNER Randall Hill
PHOTOGRAPHER
Michael Wilson
CLIENT Michael Wilson
Architectural photography

4

DESIGN FIRM
Willoughby Design Group
DESIGNER
Debbie Friday
CLIENT McKinley Marketing
Marketing and new product
development

4

McKinley Marketing Inc.

Donald M. Farquharson ■

■ President

■ 602 Westport Rd. ■ Kansas City ■ Missouri 64111

816-756-5664 ■ Fax 816-756-5446

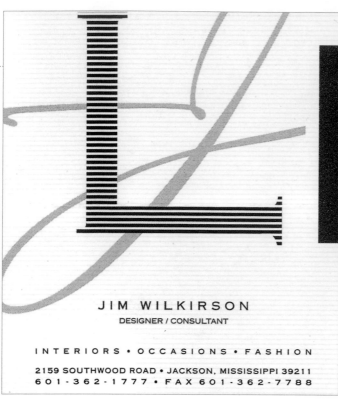

JIM WILKIRSON
DESIGNER / CONSULTANT

INTERIORS • OCCASIONS • FASHION

2159 SOUTHWOOD ROAD • JACKSON, MISSISSIPPI 39211
601-362-1777 • FAX 601-362-7788

DESIGN FIRM Communication Arts Company
ART DIRECTOR/DESIGNER Hilda Stauss Owen
CLIENT Leslie James, Ltd.
TOOLS Macintosh
PAPER/PRINTING Strathmore Elements/Offset lithography

DESIGN FIRM M-DSIGN
ALL DESIGN Mika Ruusunen
CLIENT Marika Saarinen
TOOLS Macintosh
PAPER/PRINTING Offset

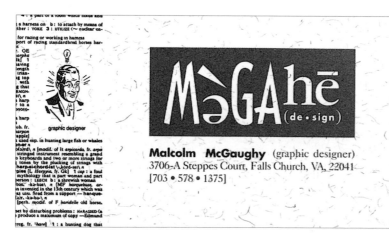

DESIGN FIRM McGaughy Design
ART DIRECTOR/DESIGNER Malcolm McGaughy
CLIENT McGaughy Design
TOOLS Macromedia FreeHand
PAPER/PRINTING Tuscan Terra, Alabaster/
Two color offset

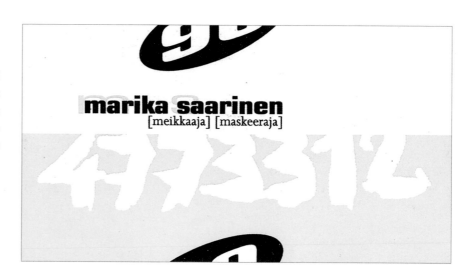

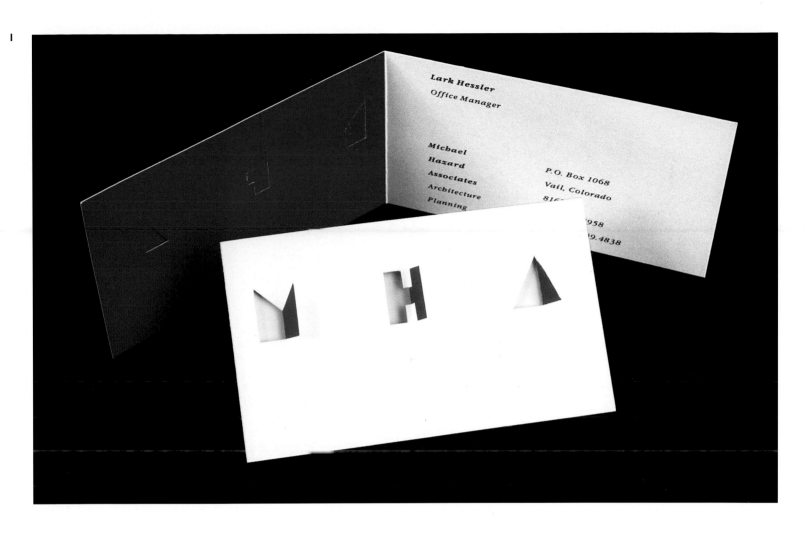

1

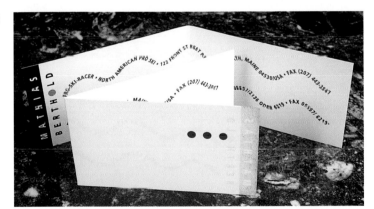

4

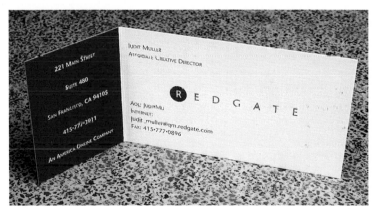

2

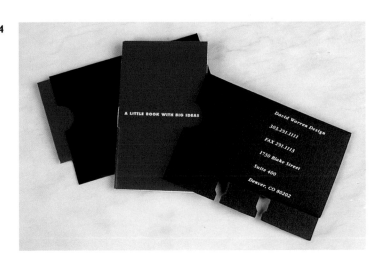

3

1

DESIGN FIRM David Warren
Design
DESIGNER David Warren
CLIENT Michael Hazard Associates
Architecture

2

DESIGN FIRM Grafik Design
Ganahl Christoph
DESIGNER Ganahl Christoph
CLIENT Mathias Berthold
Professional ski racer

3

DESIGN FIRM Regate
Communication
DESIGNER Bob Kasper
CLIENT New Media
Marketing

4

DESIGN FIRM David Warren
Design
DESIGNER David Warren
CLIENT Self-promotion
Design

1

YOUNG JU LEE

GRAPHIC
DESIGN
212.546.3482
516.767.8440

2

WILLIAM MOREE
LOCATION SCOUT

...ALL A SCOUT

800
MOREE
WT

FAX 617-423-3769 MIAMI 305-226-...

354 CONGRESS ST. BOSTON MA 02210

BOSTON LOCAL 617-426-7378

3

梅 Billy Moy

2002 Park Road
(Rib Mt. State Park)
Wausau, WI 54401

715.359.5830
1.800.290.6650
414.321.1818 *fax*

MOY'S
Rib Mountain Ginseng™

梅氏㇏山花旗蔘

梅英福

1.800.290.6650

RICK WAS BORN IN 1952 IN MANSFIELD, OHIO.
THEN HE WENT TO COLLEGE AT MIAMI UNIVERSIT...
(NOT IN FLORIDA). AND AFTER THAT HE CAME T...
CALIFORNIA AND OPENED A SMALL DESIGN STUD...
CALLED THARP DID IT. HE NOW HAS FIVE OR...
SIX OTHERS DOING IT WITH HIM. SOMETIMES T...
WIN AWARDS CERTIFICATES FOR THE STUFF THE...
DO, (USUALLY NOT ON A COMPUTER), AND HAN...
THEM ON A CLOTHESLINE ACROSS THE STUDIO. T...
WON A CLIO ONCE, BUT CAN'T FIND IT. RICK ...
NON-CORPORATE IDENTITY, PACKA...
THAT GET INTO THE SMITHSONIAN ...
Y OF CONGRESS. BIG DEAL YOU SAY? ...
THER STUFF TOO. LIKE SKI, IRON ...
PE. HE DISLIKES WHINERS, UPC ...
MOST SOFTWARE PROGRAMS EXCE ...
OR A COUPLE OF EASY ONES. H...
HAS ANOTHER OFFICE IN PORTL...
REGON WITH A CREATIVE DIREC...
FRIEND. HE DOESN'T HAVE ANY ...
KIDS THAT HE KNOWS OF. THIS ...
S PRINTED BY WATERMARK PRES...

4

#!@*

rick tharp

1

DESIGN FIRM YoungJu Lee
DESIGNER YoungJu Lee
CLIENT Self-promotion
Graphic design

2

DESIGN FIRM Paratore
Hartshorn Design
DESIGNER Paratore Hartshorn Design
CLIENT William Moree
Location scout

3

DESIGN FIRM Becker Design
ART DIRECTOR Neil Becker
DESIGNER Neil Becker, Terry Lutz
CLIENT Moy's Rib Mountain Ginseng
Ginseng mail order sales

4

DESIGN FIRM THARP DID IT
ART DIRECTOR Rick Tharp
PHOTOGRAPHER Franklin Avery
CLIENT Self-promotion
Graphic design

1

MICHAEL
JEFFCOAT

FAB
REP

301 East 7th Street
·
Suite 203
·
Charlotte, NC 28202
·
Facsimile: 704.342.0044
·
Telephone: 704.342.0000

1.800. $F_3 A_2 B_2 R_7 E_3 P_7$.

2

EAT
DESIGN

4 1 1 1 B A L T I M O R E
K A N S A S C I T Y
M I S S O U R I 6 4 1 1 1
T E L E P H O N E
8 1 6 . 9 3 1 . 2 6 8 7
F A C S I M I L E
8 1 6 . 9 3 1 . 0 7 2 3

PATRICE EILTS

3

LEAPING
LIZARDS

The
Volleyball
Team!

LOCATED ON THE COURT,
ABOVE THE NET, AND
IN YOUR FACE!

4

ELTON
WARD

ADVERTISING & DESIGN

STEVE COLEMAN
DIRECTOR

ELTON WARD

FOUR GRAND AVENUE
PARRAMATTA NSW 2124
AUSTRALIA, PO BOX 802
TELEPHONE (02) 635 6500
FACSIMILE (02) 635 3436

1 DESIGN FIRM
Mervil Paylor Design
DESIGNER
Mervil M. Paylor
CLIENT FabRep
Furniture and fabric representative

2 DESIGN FIRM
Eat Design
ART DIRECTOR Patrice
Eilts-Jobe
DESIGNER Toni O'Bryan
CLIENT Self-promotion
Graphic design and advertising

3 DESIGN FIRM
High Techsplanations
DESIGNER Mike James
CLIENT Leaping Lizards
Volleyball team

4 DESIGN FIRM
Elton Ward Design
ART DIRECTOR
Steve Coleman
DESIGNER
Chris De Lisen
CLIENT Self-promotion
Design

5 DESIGN FIRM
Barry Power Graphic Design
DESIGNER
Barry Power
ILLUSTRATOR
Everett Ching
CLIENT Everett Ching
Illustration

5

Everett Y.S. Ching
Pen & Ink Illustration
4910-4 Kilauea Avenue
Honolulu, Hawaii 96816
Telephone: 808.737.6972

陳

1

DESIGN FIRM Zedwear
ART DIRECTOR John Klaja
DESIGNER John Klaja
PHOTOGRAPHER Stuart Diekmeyer
CLIENT Self-promotion
T-shirt design and distribution

2

DESIGN FIRM Sommese Design
DESIGNER Lanny Sommese
CLIENT Self-promotion
Design and illustration

3

DESIGN FIRM Mike Quon Design Office
DESIGNER Mike Quon
CLIENT CD 101.9
Radio station

I

DESIGN FIRM Holden & Company
DESIGNER Cathe Holden
CLIENT Ducks in a Row
Interior decorating and creative services

2

DESIGN FIRM Gabriella
Hajdu-Advertising/Design
DESIGNER Gabriella Hajdu
CLIENT Self-promotion
Advertising and design

3

DESIGN FIRM Tilka Design
ART DIRECTOR Jane Tilka
DESIGNER Wendy Ruyle
CLIENT Grape Vine Catering

4

DESIGN FIRM Jay Vigon Studio
ART DIRECTOR Fred Eric
DESIGNER Jay Vigon
PRODUCER Caroline Plasencia
CLIENT Vida
Restaurant

1

2

3

4

1

DESIGN FIRM
Richardson or Richardson
ART DIRECTOR
Forrest Richardson
DESIGNER Debi Young-Mees
ILLUSTRATOR Jim Bolek
CLIENT Golf Management
International

2

DESIGN FIRM
Frank D'Astolfo Design
ART DIRECTOR Frank D'Astolfo
DESIGNER Frank D'Astolfo
CLIENT Banning Farm

3

DESIGN FIRM B.E.P. Design group
ART DIRECTOR
Jean Jacques Evrard
DESIGNER Colin Vallance
CLIENT Explotra

4

DESIGN FIRM
Colonna Farrell Design
ART DIRECTOR Tony Auston
DESIGNER Chris Mathes Baldwin
CLIENT St. Clement Vineyards

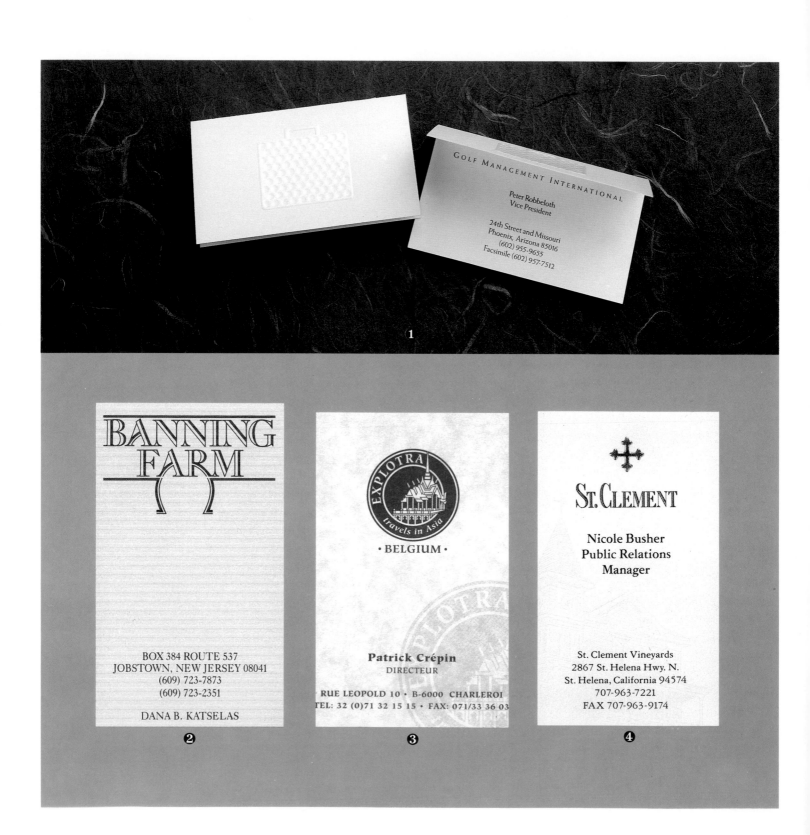

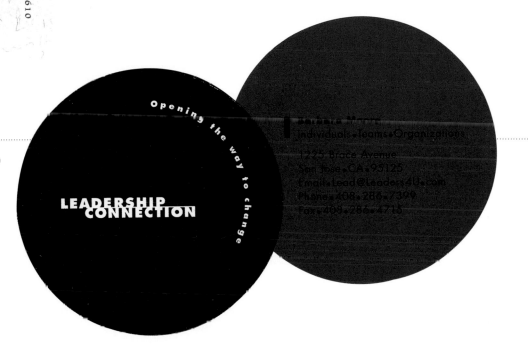

christian tours

post office box 447 blue mountain, ms 38610

barry goolsby
cruise consultant

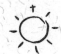

telephone 800 505 tour facsimile 601 685 9066

DESIGN FIRM David Carter Design
ART DIRECTOR Lori B. Wilson
DESIGNER/ILLUSTRATOR Tracy Huck
CLIENT Christian Tours

DESIGN FIRM Melissa Passehl Design
ART DIRECTOR Melissa Passehl
DESIGNERS Melissa Passehl,
Charlotte Lambrechts
CLIENT Leadership Connection

Opening the way to change

LEADERSHIP
CONNECTION

Barbara Morris
Individuals•Teams•Organizations

1225 Brace Avenue
San Jose•CA•95125
Email•Lead@leaders4U.com
Phone•408•286•7399
Fax•408•286•4718

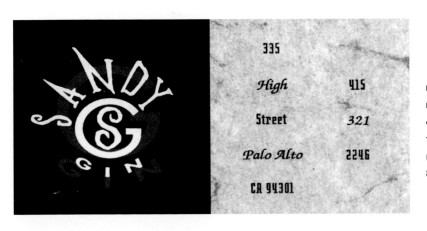

335

High 415

Street 321

Palo Alto 2246

CA 94301

DESIGN FIRM Sandy Gin Design
DESIGNER/ILLUSTRATOR Sandy Gin
CLIENT Sandy Gin Design
TOOLS Macromedia FreeHand
PAPER/PRINTING Simpson Evergreen
80 lb. cover/One-color offset

F. KENNITH NIXON

President

MENDENHALL LABORATORIES, LLC

1042 MINERAL WELLS AVE.

PARIS, TN 38242

TEL 901-642-9321

1-800-642-9321

FAX 901 644 2398

DESIGN FIRM
Greteman Group
ART DIRECTORS/DESIGNERS
Sonia Greteman, James Strange
CLIENT
Delux
TOOLS
Macromedia FreeHand
PAPER/PRINTING
Cougar white/Two-color offset

DESIGN FIRM On The Edge
ART DIRECTOR/ILLUSTRATOR Jeff Gasper
DESIGNER Gina Mims
CLIENT Five Seven Five
TOOLS Adobe Illustrator, QuarkXPress
PAPER/PRINTING Karma Natural

HAIKU/Hi-ku/n,:
An unrhymed poem or verse of three lines containing usually (but not necessarily) five, seven, and five syllables respectively.

Haiku was born in 17th century Japan. It was adopted by New York and San Francisco beat poets in the 50's with the publication of Kerouac's "Dharma Bums".

One writes a haiku to recreate an intimate moment and communicate the feelings it inspired to another.

DESIGN FIRM Hornall Anderson
Design Works, Inc.
ART DIRECTOR Jack Anderson
DESIGNERS Jack Anderson, Julie
Keenan, Mary Chin Hutchinson
ILLUSTRATOR George Tanagi
CLIENT Rod Ralston Photography
TOOLS Macromedia FreeHand

DESIGN FIRM Gini Chin Graphics
ART DIRECTOR/DESIGNER Gini Chin
CLIENT 24.7 Marketing Bloc, Inc.
TOOLS Adobe Photoshop, QuarkXPress
PAPER/PRINTING Classic Crest

DESIGN FIRM Greteman Group
ART DIRECTORS/DESIGNERS Sonia Greteman, James Strange
CLIENT Grant Telegraph Centre
TOOLS Macromedia FreeHand
PAPER/PRINTING Genesis, Sticker/Three-color offset

DESIGN FIRM
Insight Design Communications
ART DIRECTORS/DESIGNERS
Sherrie Holdeman, Tracy Holdeman
CLIENT
Insight Design Communications
TOOLS
Power Macintosh 7500,
Macromedia FreeHand, Adobe Photoshop
PAPER/PRINTING
Dull Enamel Coat 65 lb. cover

1

△RTIST
JODI L. YANCEY

615 552 2570

P.O. BOX 2344
CLARKSVILLE, TN 37042

2

Marc English

Design

37 Wellington Avenue
Lexington MA
02173-7110
617 : 860 : 0500 phone | fax

3

PRODUCTIONS di ROSSI

GABRIELLA ROSSI

4 1 5 8 5 1 4 4 3 8
1879 ANAMOR STREET
REDWOOD CITY, CA 94061

Judy Merrill
415 965 7452

4

Merrill Communications
100 E. Middlefield Road, Suite 1-D
Mountain View, CA 94043
Fax 415 965 7475
MCI Mail 443 4229
CompuServe 72634,44
Internet merrill@svpal.org

5

© CAROL VALMY-MERCHANT

V-M

COPYWRITING *for*
CREATIVE MARKETING
COMMUNICATIONS

3565 RIPPLETON ROAD
CAZENOVIA, NEW YORK 13035

315-655-8532

1

DESIGN FIRM Jodi L. Yancy, Artist
DESIGNER Jodi L. Yancy
CLIENT Self-promotion
Fine art and illustration

2

DESIGN FIRM
Marc English Design
DESIGNER Marc English
CLIENT Self-promotion
Design consulting

3

DESIGN FIRM
Stowe Designer
DESIGNER Jodie Stowe
CLIENT Productions di Rossi
Production art

4

DESIGN FIRM
Stowe Designer
DESIGNER Jodie Stowe
CLIENT
Merrill Communications
Promotion and marketing

5

DESIGN FIRM
Jowaisas Design
DESIGNER Elizabeth Jowaisas
CLIENT Carol Valmy-Merchant
Copywriter

NANCY YEASTING
DESIGN & ILLUSTRATION

3490 MONMOUTH AVENUE
VANCOUVER, B.C.
CANADA V5R 5R9

(604) 435-4965

DESIGN FIRM Nancy Yeasting
Design & Illustration
ALL DESIGN Nancy Yeasting
CLIENT Nancy Yeasting Design
& Illustration
TOOLS Hand drawn on marker pad,
QuarkXPress
PAPER/PRINTING Genesis
Milkweed/Two-color thermography

DESIGN FIRM Dhruvi Art & Design
ALL DESIGN Dhruvi Acharya
CLIENT Druvi Art & Design
PAPER/PRINTING 80/100 lbs. card
stock/Screen

DESIGN FIRM One, Graphic Design & Consulting
ART DIRECTOR/DESIGNER Aliya S. Khan
CLIENT Sabila Zakir Husnain
TOOLS CorelDraw, PC
PAPER/PRINTING Genesis Tallow

DESIGN FIRM Bartels & Company, Inc.
ART DIRECTOR David Bartels
DESIGNER/ILLUSTRATOR Aaron Segall
CLIENT Companion Baking Company
PAPER/PRINTING Mid West Printing

Angeline Beckley
DESIGNER

GASOLINE
GRAPHIC DESIGN

5704 COLLEGE AVENUE
DES MOINES, IOWA 50310
PH./FAX (515) 255-7095
GASGRAPHICS@COMMONLINK.COM

DESIGN FIRM Gasoline Graphic Design
ART DIRECTORS/DESIGNERS Zane Vredenburg, Angeline Beckley
TOOLS Adobe Illustrator, Adobe Streamline,
QuarkXPress, Adobe Photoshop
PAPER/PRINTING Neenah/Alpaca Christian Printers

WaterWorks

The Tavern

Summer House

The Oyster Bar

La Bodega

Eating Up The Coast, Inc.

Phil Cocco
Director of Operations

333 Victory Road, Marina Bay, Quincy, MA 02171
617-786-9600 • Fax 617-786-0700

DESIGN FIRM Flaherty Art & Design
ALL DESIGN Marie Flaherty
CLIENT Eating Up The Coast
TOOLS Adobe Illustrator

1

DESIGN FIRM Mervil Paylor Design
DESIGNER Mervil M. Paylor
CLIENT Ena Swansea Painting

2

DESIGN FIRM
Colonna Farrell Design
ART DIRECTOR Tony Auston
DESIGNER Tony Auston
CLIENT David Bishop Photography
and Illustration

3

DESIGN FIRM
Barry Power Graphic Design
ART DIRECTOR Barry Power
DESIGNER Barry Power
ILLUSTRATOR Barry Power
CLIENT Barry Power

4

DESIGN FIRM Deaign Farm
ART DIRECTOR Susan Sylvester
DESIGNER Susan Sylvester
ILLUSTRATOR Susan Sylvester
CLIENT Design Farm

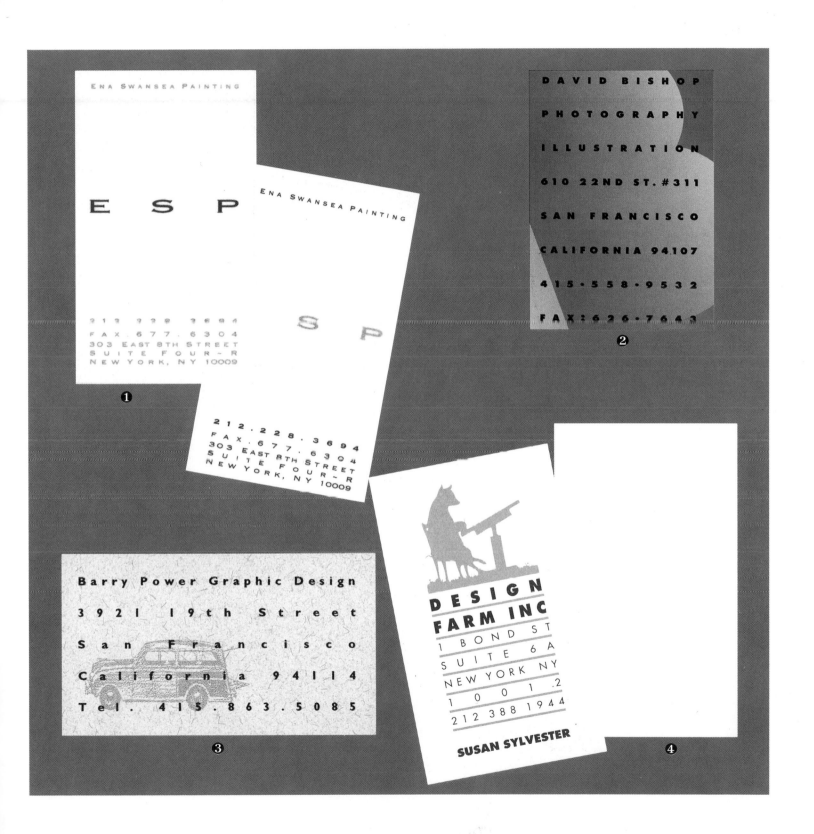

1

DESIGN FIRM
Port Miolla Associates
ART DIRECTORS
Ralph J. Miolla, Paula A. Port
DESIGNER Paul A. Port
CLIENT Self-promotion
Graphic design

2

DESIGN FIRM Karen Barranco
Design & Illustration
DESIGNER Karen Barranco
CLIENT Self-promotion
Graphic design and illustration

3

DESIGN FIRM
Cisneros Design
DESIGNER
Fred Cisneros
CLIENT John Guernsey
Photography

4

DESIGN FIRM
Modelhart Grafik Design
DESIGNER
Herbert O. Modelhart
CLIENT Self-promotion
Graphic design

1

PORT MIOLLA

Ralph J. Miolla

Designers
23 South Main Street
South Norwalk, CT 06854
203 855 0830
203 855 0856 FAX

2

karen BARRANCO

Design & Illustration

Los Angeles

California

213 848 2090

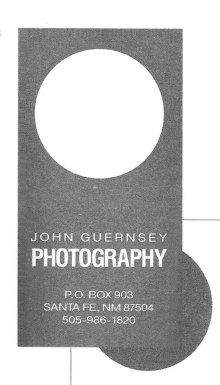

3

JOHN GUERNSEY
PHOTOGRAPHY

P.O. BOX 903
SANTA FE, NM 87504
505-986-1820

JOHN GUERNSEY
PHOTOGRAPHY

P.O. BOX 903
SANTA FE, NM 87504
505-986-1820

4

Herbert O. Modelhart grafik design

D-81673 München St.Veit-Straße 18 Tel.: 0 89 / 436 29 15
A-5600 St. Johann / Pg. Pöllnstraße 19 Tel.: 0 6412 / 63 64 o. 84 66

DESIGN FIRM
Melinda Thede
ART DIRECTOR
Lorelle Thomas
DESIGNER
Melinda Thede
CLIENT
Melinda Thede
TOOLS
Adobe Illustrator
PAPER/PRINTING
Transparency film/handmade

DESIGN FIRM MA&A—Mário Aurélio & Associados
ART DIRECTOR Mário Aurélio
DESIGNERS Mário Aurélio, Rosa Maia
CLIENT Prémaman

DESIGN FIRM
Lucy Walker Graphic Design
ART DIRECTOR/DESIGNER Lucy Walker
CLIENT Williams MacKay Advertising
TOOLS Adobe Illustrator
PAPER/PRINTING Coated artboard

1

DESIGN FIRM The Weller
Institute for the Cure of Design
DESIGNER Don Weller
CLIENT Polo Ridge Farms
Horse breeding

2

DESIGN FIRM Tangram
Strategic Design
DESIGNER Enrico Sempi
CLIENT Daniele Allegri
Painter

3

DESIGN FIRM Market Sights, Inc.
DESIGNER Marilyn Worseldine
CLIENT Atlantis Marketing Incorporated
Product and services marketing

4

DESIGN FIRM Greteman Group
DESIGNERS Sonia Greteman,
Bill Gardner
CLIENT Colorations
Film and type prepress services

1

Polo Ridge
F A R M S

RENNIE
EVERHART

8360
HELMICK ROAD
MONMOUTH
OREGON 97361
PHONE/FAX
(503)838-5704

2

Daniele Allegri

pittore

13 Corso Cavallotti, 28100 Novara, Italia
Telefono e fax 0321 623 413

3

Atlantis
Marketing
Incorporated

Trinka Tansley

4435 West Pine Boulevard
St. Louis, MO 63108
Fax (314) 535-4069
(314) 533-6040

4

Retha Petruzates
VICE PRESIDENT OF MARKETING & SALES

C O L O R A T I O N S

236 SOUTH PATTIE WICHITA, KANSAS 67211
800 279 4907 FAX 316 267 9801 TEL 316 267 5001

Ida Linnet

REKLAMEAFDELINGEN

LØVENS KEMISKE FABRIK

Industriparken 55

2750 Ballerup

Telefon 44 94 58 88

Direkte 44 92 36 66 2563

Privat 44 68 05 40

Fax 44 92 35 95

DESIGN FIRM
Department 058
ART DIRECTOR/DESIGNER
Vibeke Nødskov
CLIENT
Løvens Kemiske Fabrik
TOOLS
Adobe Illustrator, QuarkXPress
PAPER/PRINTING
Green cardboard/One color

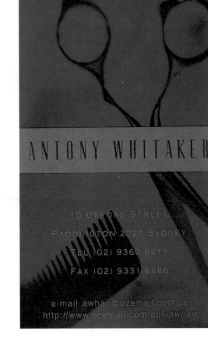

DESIGN FIRM Mother Graphic Design
ART DIRECTOR/DESIGNER Kristin Thieme
PHOTOGRAPHER Petrina Tinslay
CLIENT Antony Whitaker Hairdressing

Kimberly Bykerk, ASID

ASSOCIATE

THE RETAIL GROUP

2025 FIRST AVENUE, SUITE 470

SEATTLE, WASHINGTON 98121

FACSIMILE 206.441.8710

TELEPHONE 206.441.8330

DESIGN FIRM Widmeyer Design
ART DIRECTORS Ken Widmeyer, Dale Hart
DESIGNER/ILLUSTRATOR Dale Hart
CLIENT The Retail Group
TOOLS Power Macintosh, Adobe Photoshop,
Macromedia FreeHand
PAPER/PRINTING Environment/Offset

ART DIRECTOR/ILLUSTRATOR Ralf Huss
TOOLS Macintosh, Adobe Photoshop, QuarkXPress

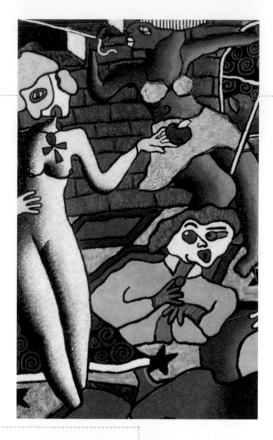

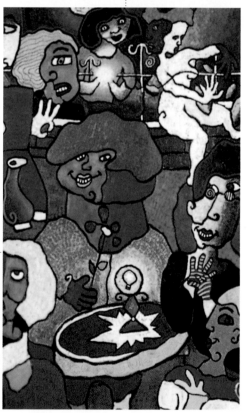

DESIGN FIRM On The Edge
ART DIRECTOR Jeff Gasper
DESIGNER Gina Mims
ILLUSTRATOR Wok
CLIENT Cafe Mojo
TOOLS Adobe Illustrator, QuarkXPress, Adobe Photoshop
PAPER/PRINTING Luna White Cover

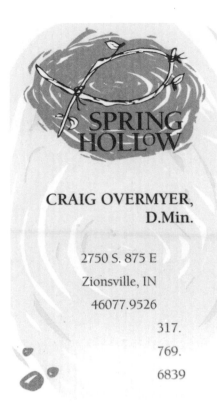

SPRING HOLLOW

CRAIG OVERMYER, D.Min.

2750 S. 875 E

Zionsville, IN

46077.9526

317.

769.

6839

DESIGN FIRM
Held Diedrich

ART DIRECTOR
Doug Diedrich

DESIGNER/ILLUSTRATOR
Megan Snow

CLIENT
Spring Hollow

TOOLS
QuarkXPress, Adobe Illustrator

PAPER/PRINTING
Neenah, Classic Laid,
Natural White/Offset

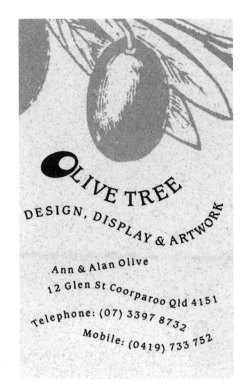

OLIVE TREE
DESIGN, DISPLAY & ARTWORK

Ann & Alan Olive
12 Glen St Coorparoo Qld 4151
Telephone: (07) 3397 8732
Mobile: (0419) 733 752

DESIGN FIRM Olive Tree
ART DIRECTOR/DESIGNER Alan Olive
ILLUSTRATOR Kent Smith
TOOLS CorelDraw
PAPER/PRINTING Edwards Dunlop
Recycled Evergreen

CUSTOM SAFETY FLOOR MATTING

sbemco

INTERNATIONAL, INC.
715 NORTH FINN DRIVE ALGONA, IOWA 50511

BRIAN BUSCHER
President

TEL. (515)295-3902
(800)468-0860
FAX: (515)295-9545

DESIGN FIRM Sayles Graphic Design
ALL DESIGN John Sayles
CLIENT Sbemco International
PAPER/PRINTING Curtis Retreeve white/Offset

GARDNER GRAPHICS

2200 Sixth Avenue
Suite 1103
Seattle, WA 98121

g

P / FAX: (206) 441-8914 (By Appt.)

DESIGN FIRM Gardner Graphics
ALL DESIGN Dianne Gardner
CLIENT Dianne Gardner
TOOLS Adobe Photoshop
PAPER/PRINTING Coated

1

SunSpot
QuickGreen Cuisine℠

Naturally-Healthy
Environmentally-Friendly
Fast-Food

2510 NE Blakeley · Seattle 527.2831
Just north of the University Village
Across from the Burke-Gilman Trail

BREAKFAST·LUNCH·DINNER·CATERING

ROLLUPS·NOODLES·SALADS·SOUPS
SPRITZERS·JUICES·BAKED GOODS

2

Red Rooster
COFFEE COMPANY

DEBBY WALLACE
PROPRIETOR

P.O. BOX 720695
SAN JOSE, CA 95172
PH. & FAX. [408] 998-7025

1

DESIGN FIRM
Sunny Shender Design
DESIGNER Sunny Shender
ILLUSTRATOR Scott Mussgrove
CLIENT Sunspot Quick
Green Cuisine
Fast food and health food retail

2

DESIGN FIRM JWK Design
ART DIRECTOR Jennifer Kompolt
DESIGNER Patrick Keller
CLIENT Red Rooster
Coffee Company
Coffee wholesale

3

DESIGN FIRM DeGroot
DESIGNER Gert Jan de Groot
CLIENT Self-promotion

4

DESIGN FIRM Kaiser Dicken
ART DIRECTOR Craig Dicken
DESIGNERS Debra Kaiser,
Craig Dicken
ILLUSTRATORS Debra Kaiser,
Craig Dicken
CLIENT WEXP
Radio station

4

Laurie Collins
Account Executive

PO Box 105
192 College Street
Burlington, Vermont 05402
802.860.1051
Fax 802.860.1960

W E X P

3

Gert Jan de Groot
ART& ILLUSTRATION
Gert Jan de Groot Rue Brisee 241 7020 NIMY BELGIUM 065730429

DESIGN FIRM LSL Industries
DESIGNER Franz M Lee
CLIENT LSL Industries
TOOLS QuarkXPress, Adobe Photoshop
PAPER/PRINTING Encore 130 lb. gloss

DESIGN FIRM Tanagram
ART DIRECTOR Lance Rutter
DESIGNER David Kaplan
CLIENT Alpha Dog
TOOLS Macromedia FreeHand,
Adobe Streamline
PAPER/PRINTING Strathmore Elements

DESIGN FIRM Mirko Ilić Corp.
ART DIRECTOR/DESIGNER Nicky Lindeman
CLIENT La Paella Restorante
TOOLS Adobe Illustrator
PAPER/PRINTING Cougar 80 lb. white smooth
cover/Rob-Win Press

FITZHUGH L. STOUT

& ASSOCIATES

FITZHUGH L. STOUT, MAI
Real Property Appraiser
and Consultant

505 East Boulevard
Charlotte, North Carolina 28203
704·376·0295
Facsimile 704·342·3704

1

ADVERTISING / GRAPHIC DESIGN

SHIELDS DESIGN

Charles Shields

415 East Olive Avenue
Fresno, California 93728
209·497·8060
FAX: 209·497·8061

2

HORTICA
URBAN GARDENS

Judith L. Musick

566 Castro Street
San Francisco 94114
tel 415.863.4697
fax 415.863.1024

3

SUITE 102

A FULL DAY SPA

DORA TEMPLES
6201 ANTIOCH ST. SUITE 102
OAKLAND, CA 94611
415 / 339 - 8181

4

YOUR NEXT
APPOINTMENT

DATE

TIME

5

林國隆
縣水里鄉
一〇號聲里簡
七九聲里筒頂傳
七六七〇四
五七四崁村南投
四傳九眞九窯落
九眞一〇七四

1

DESIGN FIRM Mervil Paylor
Design
DESIGNER Mervil M. Paylor
CLIENT Fitzhugh L. Stout &
Associates
Real estate appraisal

2

DESIGN FIRM Shields Design
DESIGNER Charles Shields
CLIENT Self-promotion
Advertising and graphic design

3

DESIGN FIRM Barry Power
Graphic Design
DESIGNER Barry Power
CLIENT Hortica Urban Gardens
Flower nursery

4

DESIGN FIRM
B3 Design
DESIGNER Barbara B. Breashears
CLIENT Suite 102
Spa

5

DESIGN FIRM Mitsuta
ART DIRECTOR Shiann-juh Lai
DESIGNER Pey-yng Lin
ILLUSTRATOR Shiann-juh Lai
CLIENT Shui-Li Snake Kiln
Ceramics Cultural Park

Oak Systems

Harold Shore

10201 Wayzata Boulevard
Suite 320
Minnetonka, MN 55305

Work (612) 542-8910
Fax (612) 595-8227
E-mail: hshore@OAKSYS.COM

DESIGN FIRM Design Center
ART DIRECTOR John Reger
DESIGNER Sherwin Schwartzrock
CLIENT Oak Systems
TOOLS Macintosh
PAPER/PRINTING Procraft Printing

DESIGN FIRM M-DSIGN
ALL DESIGN Mika Ruusunen
CLIENT Kai Vähäkuopus
TOOLS Macintosh
PAPER/PRINTING Offset

DESIGN FIRM Design Ahead
DESIGNER Ralf Stumpf
CLIENT Ralf Stumpf
TOOLS Macromedia FreeHand, Macintosh

DESIGN FIRM LSL Industries
DESIGNER Elisabeth Spitalny
CLIENT JP Davis & Co.
TOOLS QuarkXPress
PAPER/PRINTING French Newsprint White

77

DESIGN FIRM Shari Flack
ART DIRECTOR Shari Flack
DESIGNER Shari Flack
COPYWRITER Shari Flack
CLIENT Shari Flack
PAPER Arvey
TOOL QuarkXPress

Used as a follow-up piece for résumés, this brochure was photocopied in-house to save costs, then assembled by hand.

1

Beatty·Levine Inc. EVENT PRODUCTION & DESTINATION MANAGEMENT

VICKI EMERICK
DIRECTOR OF
PROGRAM FINANCE

4100 Newport Place
Suite 220
Newport Beach
California 92660
714.251.1111
Fax 714.251.1137
LA 310.598.0085

2

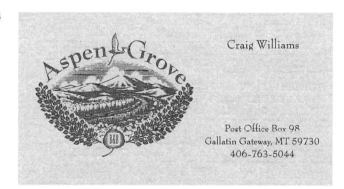

TRAVIS POWELL

415 574 5894

EVENT / MEDIA
PRODUCER

FULL PRODUCTION MANAGEMENT
- EVENTS
- VIDEO
- PRINT

37 TWELFTH AVENUE
SAN MATEO, CA 94402
FAX 415 574 5894

3

PREC|SION

Lisa Whitaker
President

Precision Sampling
Incorporated
958 San Leandro Avenue
Suite 900
Mountain View, CA 94043
415 967 8717
FAX 962 0612

4

Craig Williams

Aspen Grove

Post Office Box 98
Gallatin Gateway, MT 59730
406-763-5044

5

Luma

at THE BROADMOOR

1 Design Firm
Vaughn Wedeen Creative
Art Director
Rick Vaughn
Designer
Dan Flynn
Client
Beatty Levine Inc.
*Event production and
destination management*

2 Design Firm
Stowe Designer
Designer
Jodie Stowe
Client
Travis Powell
Event/media production

3 Design Firm
Curtis Design
Designer
David Curtis
Client
Precision Sampling Inc.
Soil sample drilling

4 Design Firm
Palmquist & Palmquist Design
Designers
Kurt Palmquist, Denise Palmquist
Illustrators
Jim Lindquist, Kurt Palmquist
Client
Aspen Grove B & B
Bed and breakfast

5 Design Firm
Marsh, Inc.
Designer
Greg Conyers
Client
Luma
Handmade objects gift shop

. . . snip-snip, snippety-snip . . .

Adventures in Art

"Paper cut-outs enable me to draw directly on colour . . . Instead of drawing an outline and filling in the colour . . . I draw directly into colour."

Henri Matisse

Cut-Out Fun with

matisse

Make your own cut-outs

like Matisse!

Prestel

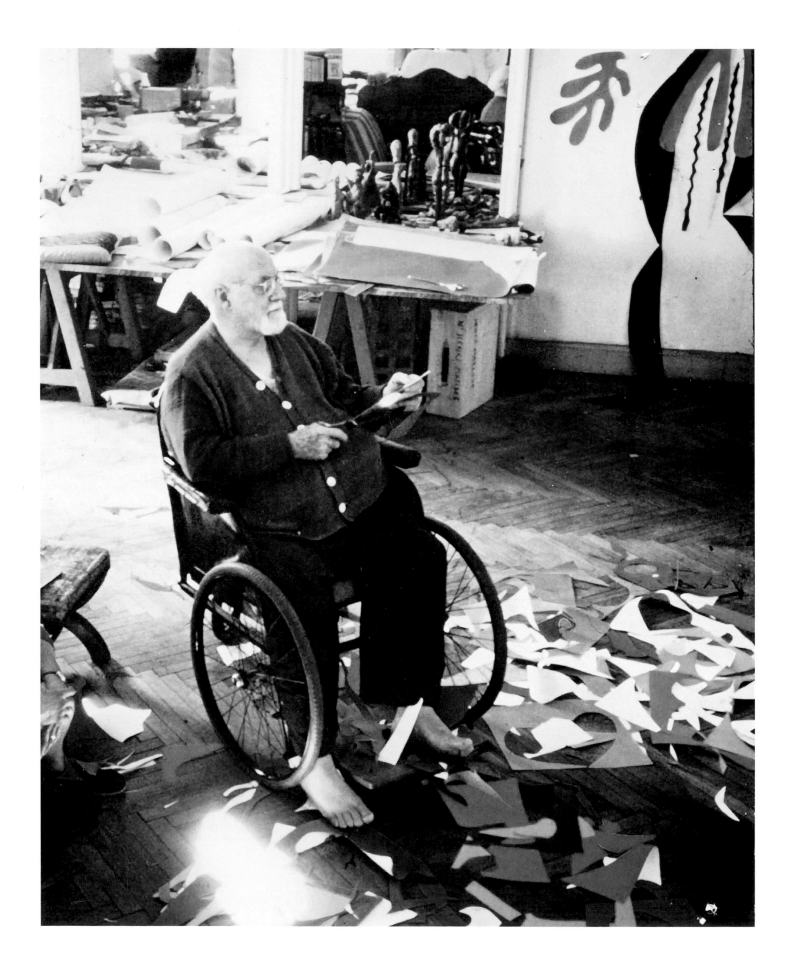

In the town of Nice on the French Riviera there is a very old building called the Hotel Régina. People say that there are strange goings-on in a certain room on the third floor . . . Sometimes, if you listen at the door, you can hear the oddest sounds and the light often stays on late into the night. A few months ago, an old man with a white beard moved in there. His name is Henri Matisse and he has just discovered something amazing—how to draw with scissors!

He is sitting in a wheelchair in his room, with paper scattered around him all over the floor, cutting out shapes—wonderful shapes—from huge sheets of coloured paper. Large, small, curved, wavy, round, pointed, zigzag shapes, squares, hearts, crosses, stars, leaves, crescents, apples, seaweed shapes, letters of the alphabet . . . every possible shape you can imagine. He has taken off his shoes and is shuffling the pieces of paper around on the floor with his bare feet to get a better look at them, arranging them with his toes, and all the while snipping away with his scissors.

snip-snip, snippety-snip

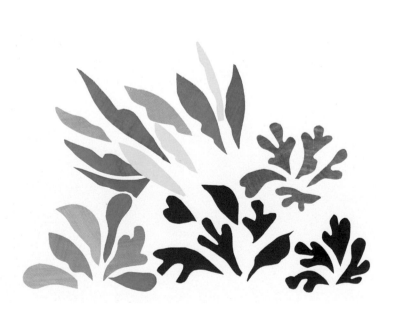

The walls of the room are covered with hundreds of cut-out shapes in patterns that go all the way up to the ceiling. "Drawing with scissors . . . cutting directly into colour . . ." mumbles Matisse, stopping for a moment to straighten a few particularly well-cut blue shapes on the wall.

He likes what he sees.

Lost in thought, Matisse gazes at the shapes he has made.

Suddenly, the wall seems to flicker before his very eyes. Everything begins to blur. The blue paper shapes move all by themselves. A graceful young woman, wearing not a stitch of clothing, sits down in front of Matisse. She crosses her legs and looks him straight in the eye.

"Henri," she says in a quiet, gentle voice: "You have drawn me and painted me many times. And yet I hardly know you. Tell me, what is your greatest wish?"

Matisse thinks for a moment and says: "To see the world through the eyes of a child."

The woman smiles. "The answer lies in your hands."

"What do you mean?" asks Matisse. Then he looks down and sees the scissors in his hand and starts snipping away again, cutting shapes out of the coloured paper, getting better and better all the time.

. . . snip-snip, snippety-snip . . .

Quietly, rhythmically: snip-snip, snippety-snip . . . almost like a melody played on piano, saxophone and drums. Everything in the room seems to move to the beat, even the paper shapes on the wall.

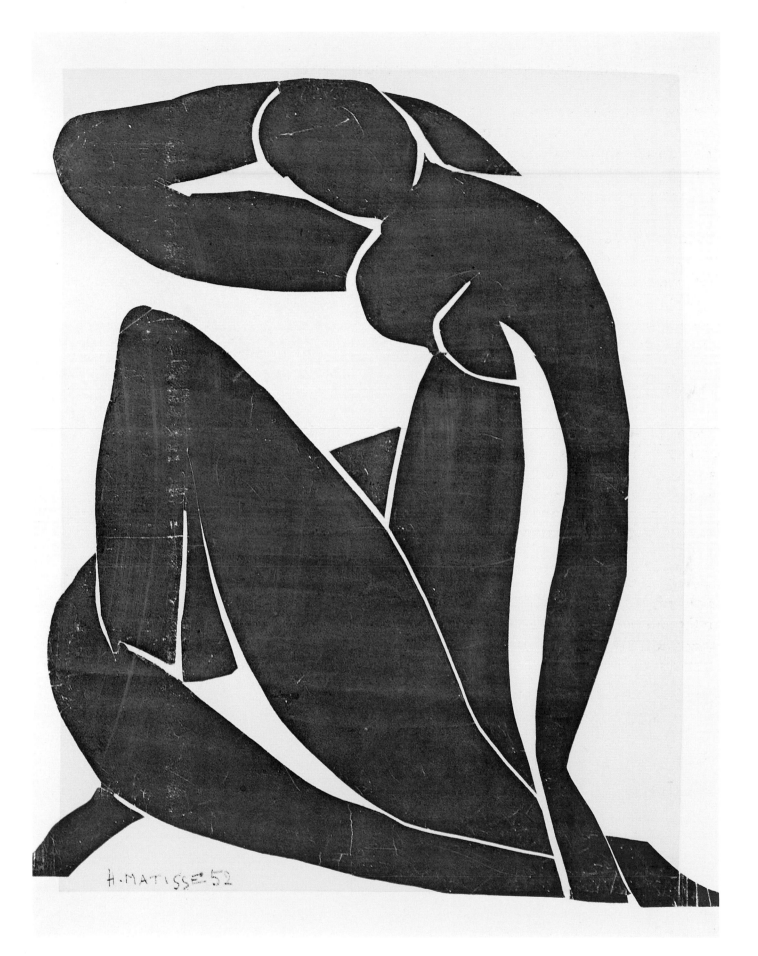

The young woman is no longer sitting cross-legged on the floor.
She has stood up and has begun to dance to the music.

She swings her legs up over her head like an acrobat, then she
takes a blue rope and sweeps it up over her head and down
again beneath her feet. She is hopping and skipping in a graceful
dance.

Soon, the walls of the room are too small for her, and her
skipping rope keeps catching on the door frame and pieces
of furniture.

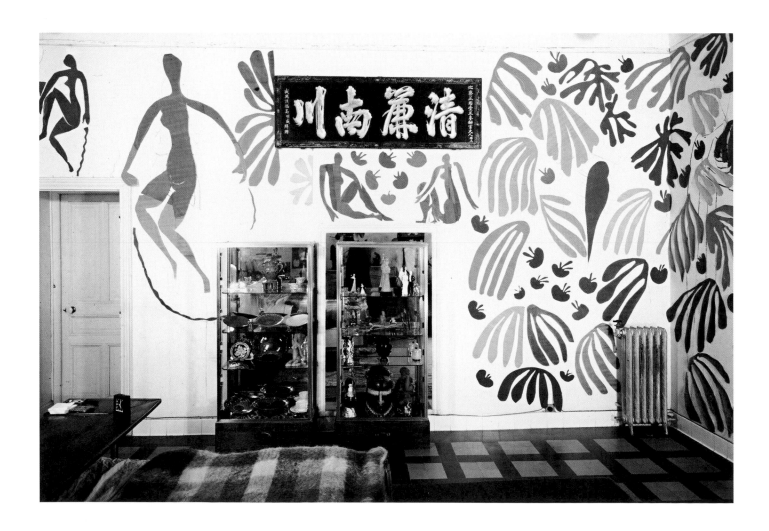

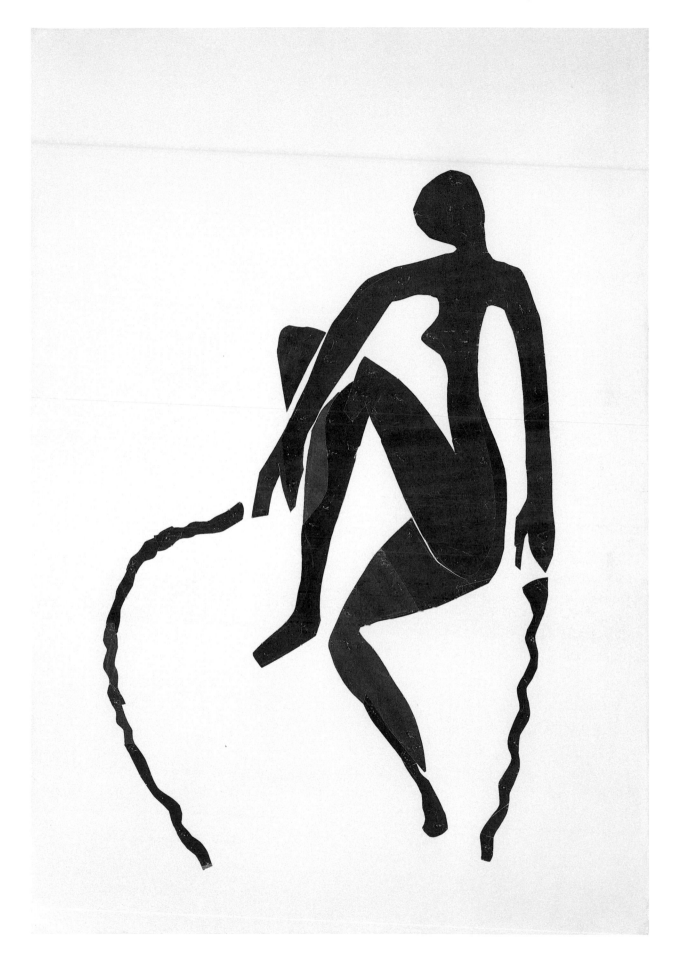

Things are happening on the opposite wall, too. With a whoop of joy, another dancer leaps up and turns a cartwheel. She moves so fast across her orange mat that we just catch a glimpse of her black legs and arms among the white feathers of her dress.

Nearby, above a dark wooden chest of drawers and behind the flowers, something else is moving. Two large shapes—it's hard to tell whether they are figures or statues or even spinning tops or vases—start swaying to the rhythm of the music. It is not easy for them to keep their balance. The silvery-white shape on the left is a little lighter and more supple. The blue shape on the right is heavier and has difficulty keeping up with the figure on the left.

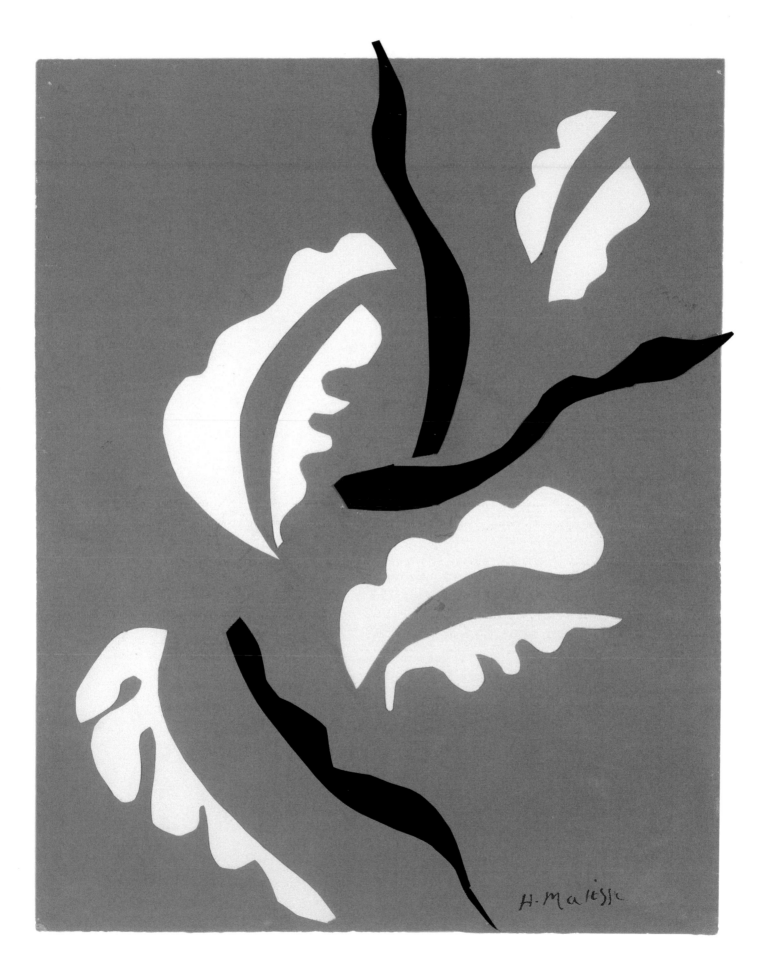

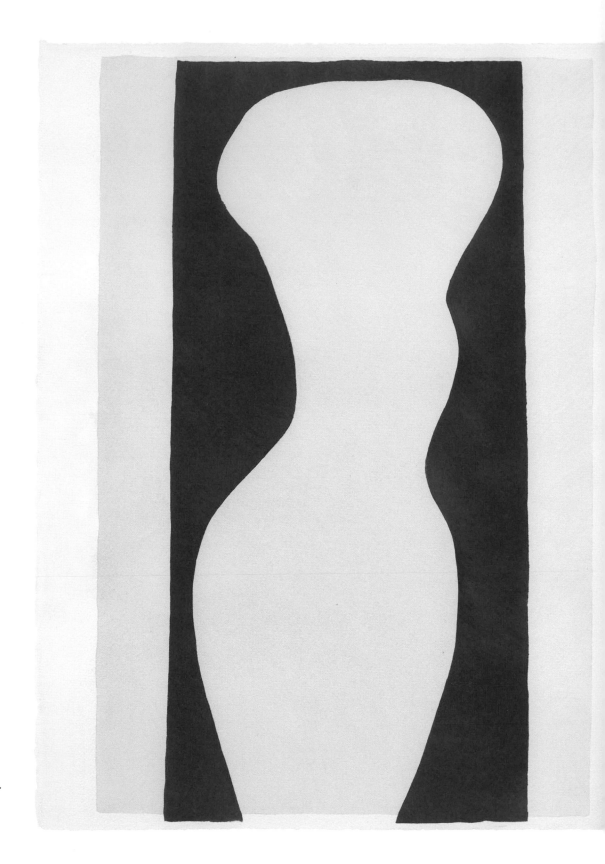

Matisse can hardly
believe his eyes. After
a while, it all gets too
much for him.

12

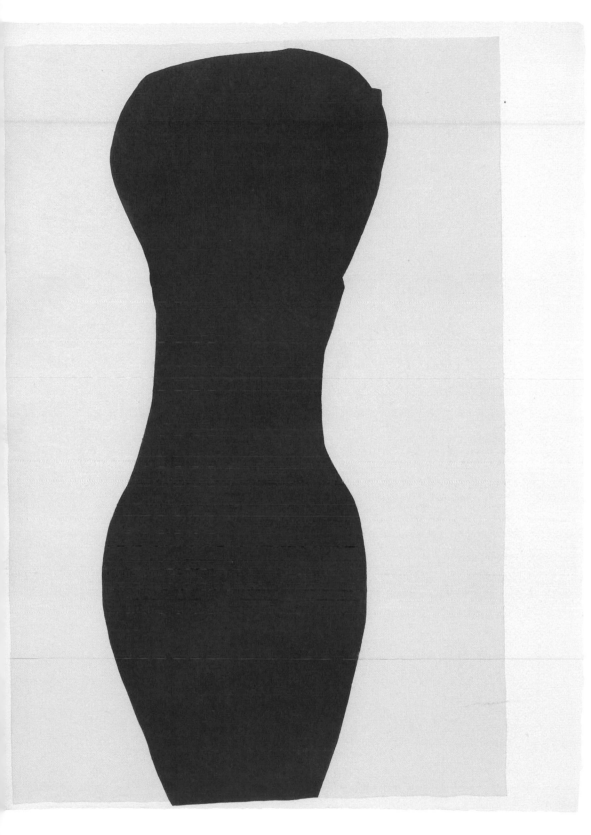

"Stop! Enough of that!
My curved lines are not
so wild. All cut-outs
go back to your places
now—exactly where
I put you!"

Luckily, he remembers that he cut out a bell shape for the top
corner of the room not so long ago. He takes a good look at
the bell, trims it a little with a quick snip-snip of his scissors,
until it is just right—and suddenly it gives out a long, loud peal
like a gong.

At the sound of the bell, everything goes quiet.

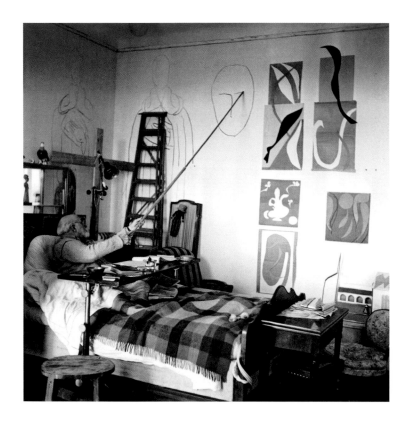

Next morning, Matisse is feeling a little
tired after all the excitement of the night
before. He is a frail old man, even though
he is full of the joys of life. He decides
to sit up in bed to do some drawing with
the help of a long stick. He ties a piece
of chalk to the end of it and traces the
outline of a face on the wall.

As he does so, he thinks how wonderful it would be to travel
to the South Seas instead of sitting here in bed. And then he
remembers: "The answer lies in your hands" . . . and he picks
up the scissors from his bedside table.

 . . . snip-snip, snippety-snip . . .

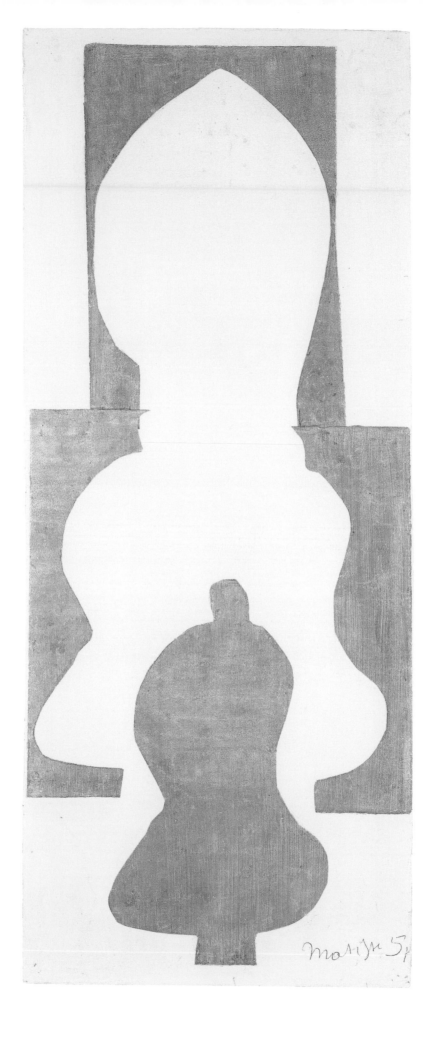

The room is getting warmer. A pleasantly heavy, tropical breeze wafts through the window. The wonderful smell of flowers fills the room and there is a quiet buzz in the air. Suddenly, a swarm of bees flies over Matisse and his bed in a shimmering, vibrant cloud of red, blue and yellow. The bees sweep round in a huge arch across the wall of the room and fly away as a soft, warm rain begins to fall.

A tropical rainstorm!

Within a very short
time, three of the walls
are covered in water.

Matisse watches, delighted,
as several blue figures
dive into the water and
swim around like fish.
They float on their backs,
dive through the waves,
and leap like dolphins.

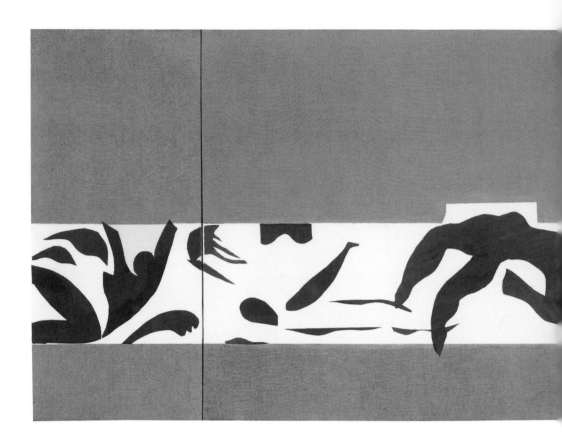

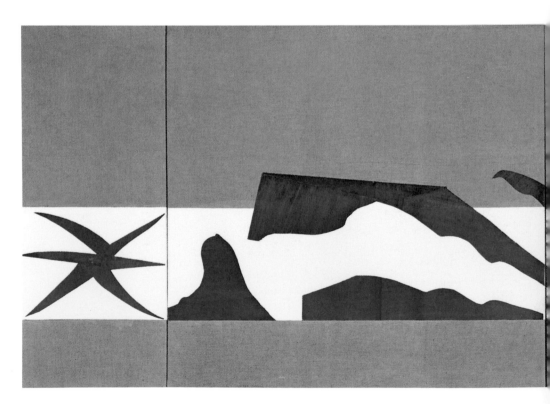

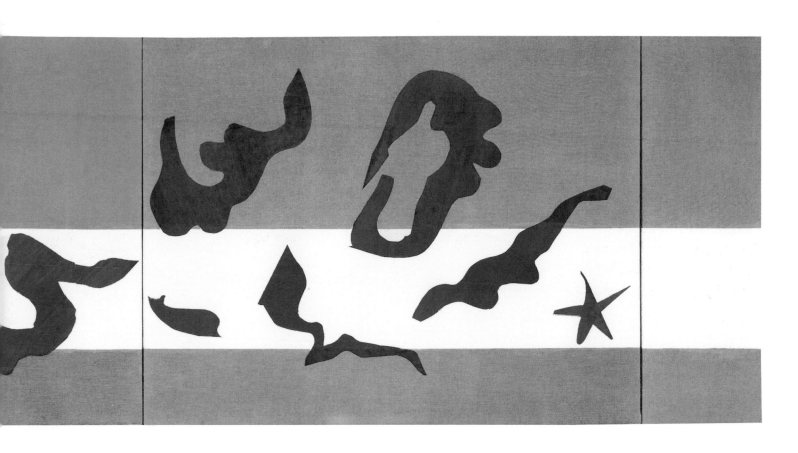

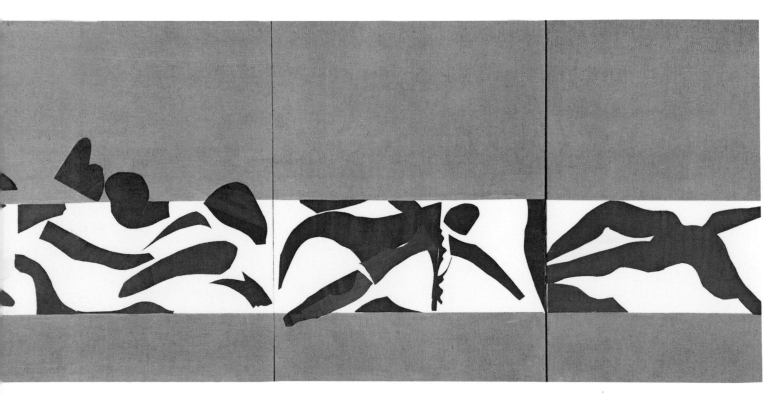

They remind Matisse of an exciting voyage he once made
twenty years ago to Tahiti and the island of Bora-Bora.

His scissors curve and circle through the paper,
flying like a bird in his hand.

The fine, white sand and a beautiful underwater paradise
—fish, starfish, whelks, little polyps and a whole world
of underwater plants—are all swimming on his walls.

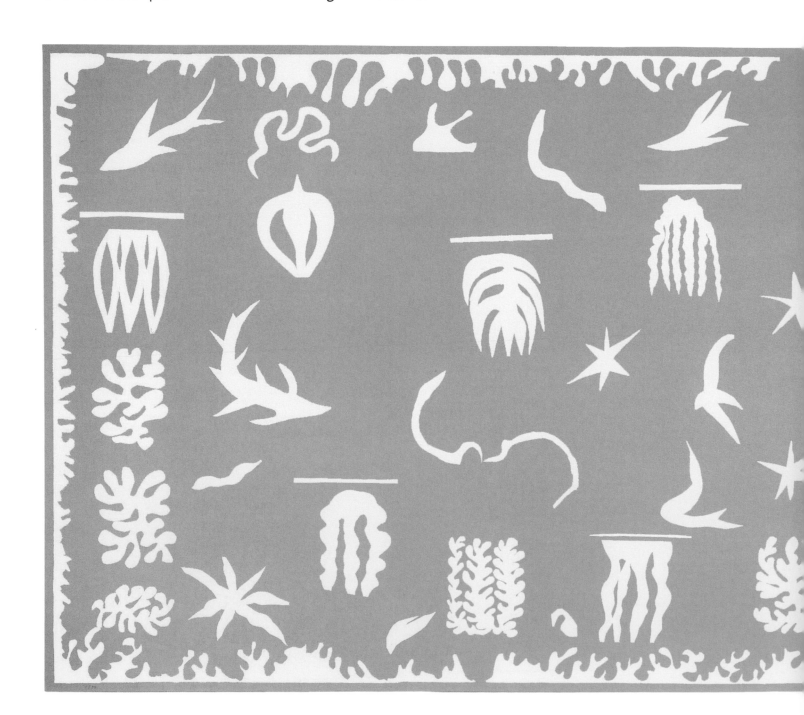

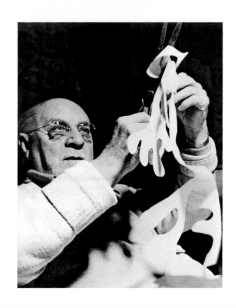

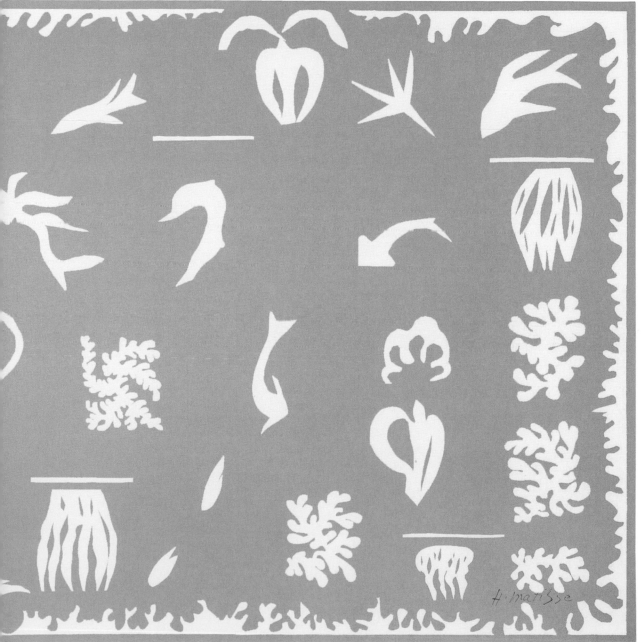

The sea glitters in many colours. Green, red, orange and blue
leaves and seaweed slowly sink towards the seabed. Between
them, azure-blue fruit is floating around and, for a moment,
a beautiful mermaid appears, dancing gracefully around the
plants. A cheeky little puffin flutters down from the wall and
lands on the artist's shoulder, where it turns into a white dove.

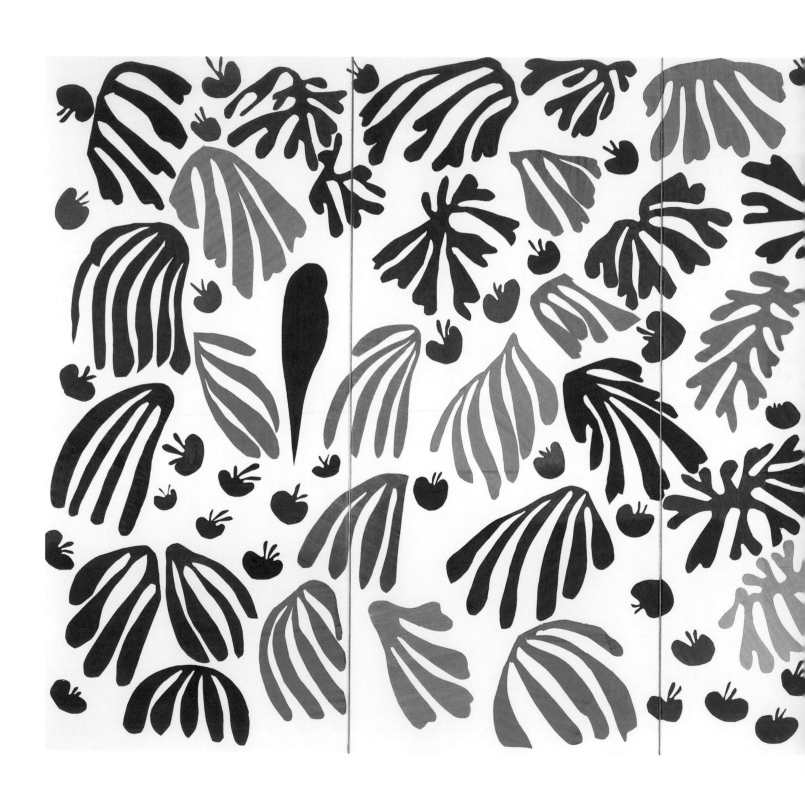

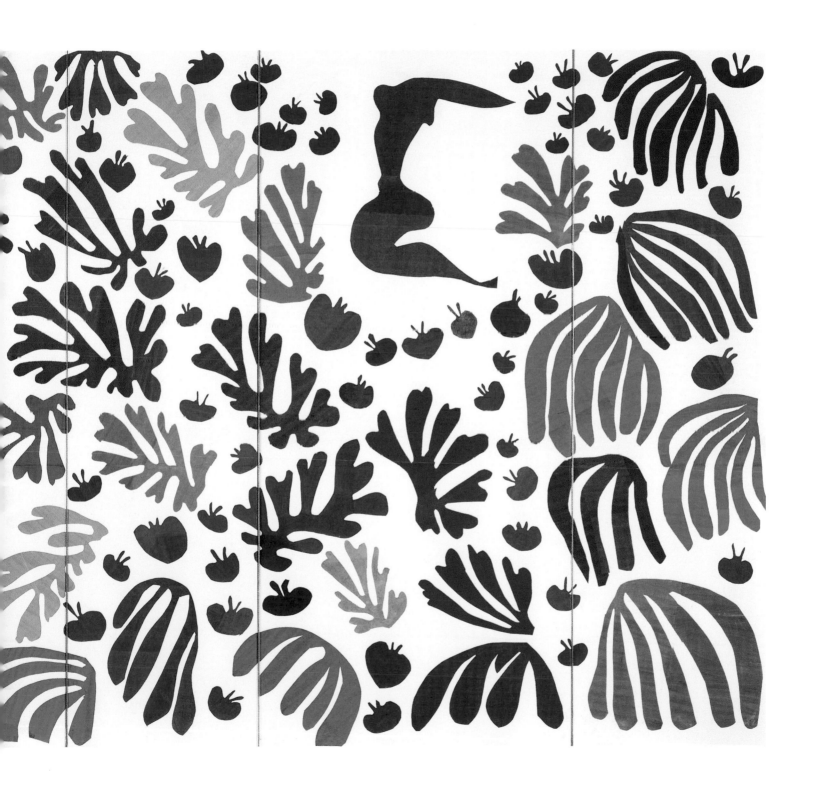

Together, the artist and the bird gaze in admiration
at the magnificent colours of the corals and the water—
an ocean of brightly coloured seaweed as far as the eye
can see. Matisse feels a thrill of pleasure, as though
he had just seen something quite wonderful for the
very first time in his life—curious, astonished, inspired
and free of gloomy thoughts.

Now he knows what it is like to see the world through
the eyes of a child!

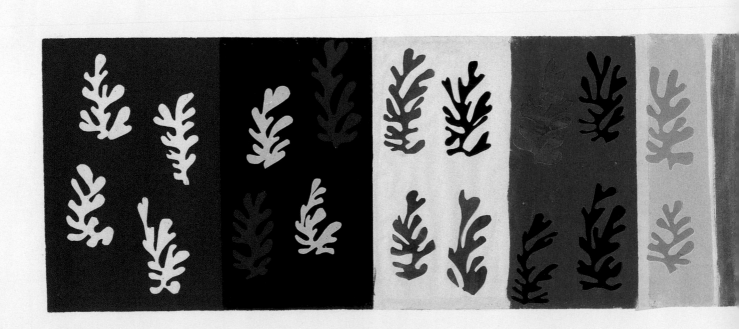

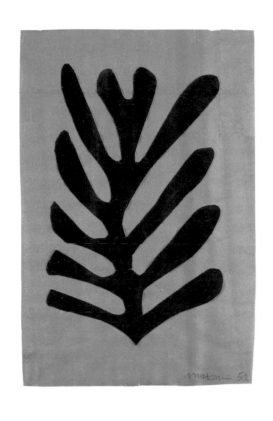

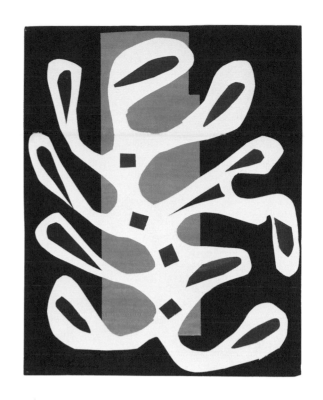

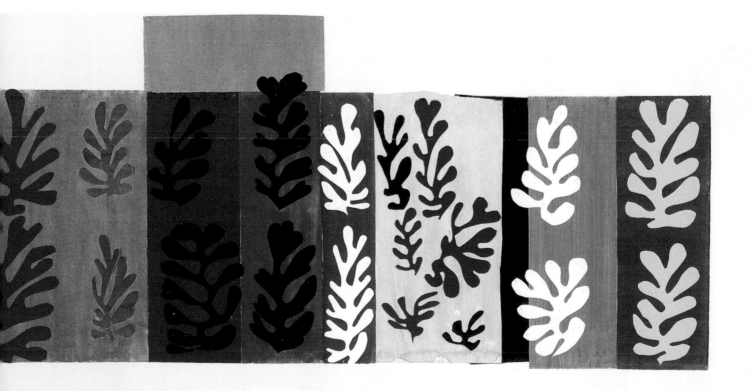

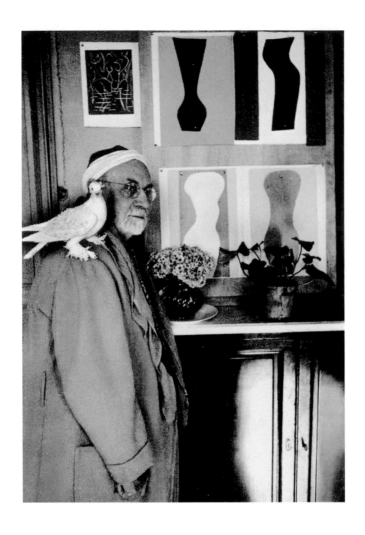

"Scissors are a wonderful tool . . . ," whispers Matisse to the bird on his shoulder. "Working with paper and scissors is something I could really become interested in . . . I am growing to like making cut-outs more and more. Why didn't I think of this before?"

At last, night falls on Tahiti. The water of the sea turns a deep, dark blue. A black seaweed shape, strange and beautiful, appears for a moment, only to sink slowly down into the endless depths.

. . . snip-snip, snippety-snip . . .

Matisse then sets his scissors aside.

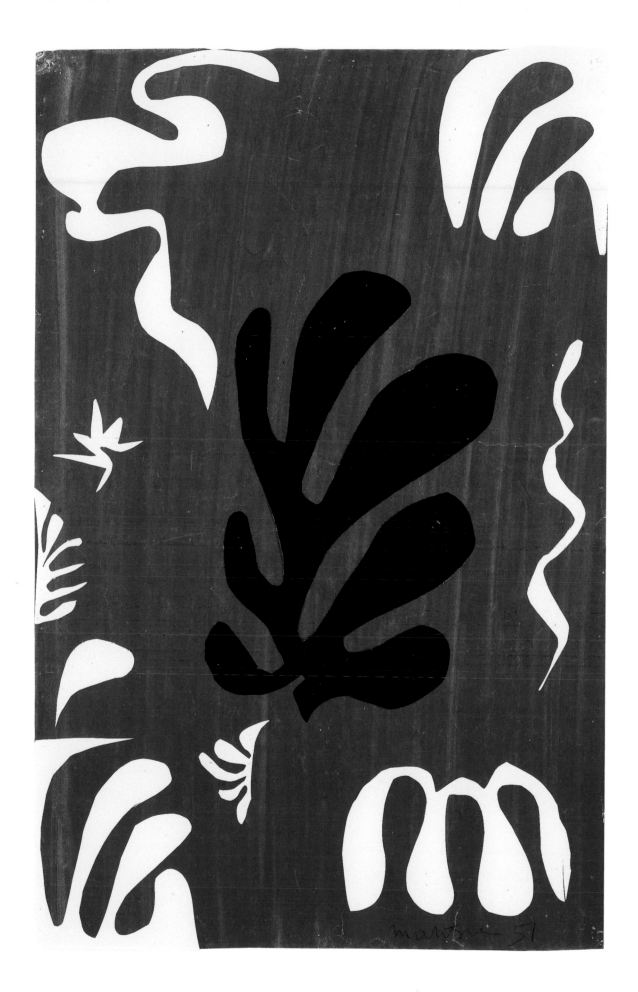

About the artist

Henri Matisse was born in 1869 in Le Cateau-Cambrésis in the north-east of France. He decided to become an artist when he was twenty-one years old, and went to live in Paris. Travelling became more and more important to him, and he would sometimes go on journeys for several months, not just because he was fascinated by foreign countries and unfamiliar cultures, but also because he enjoyed meeting other artists, collectors and art lovers.

Paris Switzerland Morocco

Algeria Tangiers Antibes

Sweden Italy Tahiti

Moscow Bora-Bora

London San Francisco Papeete

Issy Florence

Spain Bordeaux

Venice

Germany Padua Seville

Marseilles New York

Berlin Basle

Nice

Matisse's work was soon being shown in museums and galleries all over the world. By this time, he was travelling a lot between Paris, Issy-les-Moulineaux and the area around Nice, where he later lived at the Hotel Régina. His wife Amélie, their sons Jean and Pierre, and their daughter Marguerite, would often join him.

Matisse worked very hard. Even when he became old and frail and was too ill to leave his bed, he took every opportunity to turn his ideas into reality—when he was in bed, for example, he still managed to work on his cut-outs.

Matisse died in Nice in 1954. He was eighty-five years old.

"Basically, there is only Matisse," his friend Picasso once said. Perhaps Picasso meant that the perfection Matisse had reached in his art could hardly be topped. Some of Matisse's pictures are now so famous that they have simply become part of our lives. The wonderful lines and colours are familiar to many of us that we may somehow recognise them when we see them, even if we do not always remember the artist's name right away, or are not sure when or how they were made.

What are cut-outs?

When the young Henri Matisse (who was working as a lawyer's assistant) had to spend almost a year in bed after a serious intestinal operation at the age of twenty-one, his mother Anna gave him a paintbox so that he would not get bored.

What a wonderful present!

That was how Matisse began a new life as an artist. Best of all, he liked to paint and draw landscapes, people and faces, but he also painted vases of flowers, bowls of fruit and even rooms.

Later, he liked trying to create pictures with as few lines and colours as possible. This was how he developed his special technique of cut-outs, which was a very important part of his work from the mid 1940s onwards. In fact, Matisse's famous cut-outs are often said to be his greatest works.

To make his cut-outs, Matisse would use scissors to cut shapes out of sheets of coloured paper. Then, he would arrange them very carefully to create a large picture and fix them to a surface—usually the walls of his room.

These works were the fulfilment of his life's dream: the perfect interaction of line and colour. Matisse no longer drew a person or object with a pencil and then coloured it in. Instead, he worked straight into the colour by cutting shapes out of sheets of coloured paper—just as a sculptor hews directly into stone in order to make a figure out of a formless block. In much the same way, Matisse uses only one colour, so that colour and form become one and the same.

Although we can always recognise the shapes Matisse makes, they are very simple compared to reality. For instance, when Matisse cuts out an apple, it does not look exactly like a real apple. It looks the way Matisse sees an apple. The cut-out figures and objects often form patterns which Matisse worked out very carefully and arranged to make a picture. Some of these works are huge—covering the wall of a room—while others are very small, as small as this page. All of them give us an idea of a beautiful paradise on earth, and show us how much Matisse loved life and enjoyed art.

Make your own cut-outs

Would you want to have a go?
It really isn't difficult.
All you need is a pair of scissors and some coloured paper.

In order to get exactly the colour he wanted for his cut-outs,
Matisse mixed his own colours and used them to dye the paper.
This book contains a few sheets of paper in the same colours
that Matisse used.

What would you like to cut out?

Some seaweed?

Or an apple?

A leaf?

Or something else?

Why not give it a try?

 . . . snip-snip, snippety-snip . . .

You can then stick the cut-outs onto a sheet of paper.
Or you might want to decorate the walls of your room with them.

snippety-snip
snippety-snip

List of Illustrations

Texts in blue are Matisse quotations

Photographic Credits

Jens Riehe: front cover, p. 9; Helene Adant, Paris: p. 4; Dimitri Kessel, Lifephoto, Paris: p. 8; Christopher Burke, New York: p.11; Paris Match/ Carone,Paris: p. 14; François Fernandez: pp. 16/17; Ricardo Blanc: pp. 20/21; Cameraphoto, Venice: p. 21 (top); Hickey-Robertson: pp. 24/25 (top left); Martin Bühler: pp. 24/25 (bottom) Henri Cartier-Bresson, Magnum/Agentur Focus: p.26

Text and picture selection by **Nina and Max Hollein**

For Loys

The Library of Congress Cataloguing-in-Publication data is available. The Deutsche Bibliothek holds a record of this publication in the Deutsche Nationalbibliografie; detailed bibliographical data can be found under: http://dnb.ddb.de

© Prestel Verlag, Munich · London · New York 2014
© 2013 of works illustrated, by the Succession Matisse/ VG Bild-Kunst, Bonn

Prestel, a member of Verlagsgruppe Random House GmbH

Prestel Verlag, Munich
www.prestel.de

Prestel Publishing Ltd.
14-17 Wells Street
London W1T 3PD

Prestel Publishing
900 Broadway, Suite 603
New York, NY 10003

www.prestel.com

Prestel books are available worldwide. Please contact your nearest bookseller or one of the above addresses for information concerning your local distributor.

Translated from the German by Ishbel Flett, Edinburgh
Edited by Christopher Wynne

Design and layout: Meike Sellier, Eching
Originations: ReproLine Mediateam, Munich
Printing and Binding: Printer Trento, Trento

Printed in Italy

Verlagsgruppe Random House FSC® N001967
Das für dieses Buch verwendete FSC®-zertifizierte Papier *Hello Fat matt* wurde hergestellt von mill Condat, Le Lardin Saint-Lazare, France.

ISBN 978-3-7913-7192-4